The
Three
Incestuous
Sisters

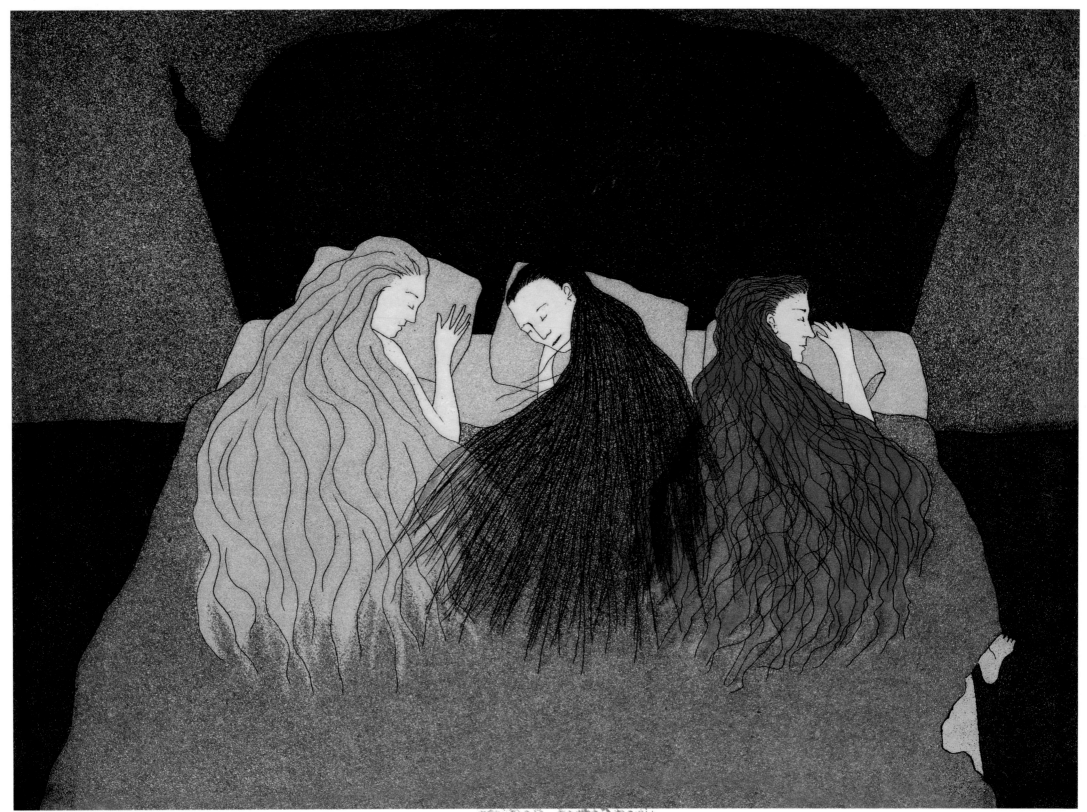

The
THREE
INCESTUOUS
SISTERS

AUDREY NIFFENEGGER

Harry N. Abrams, Inc., Publishers

Editor: Tamar Brazis
Designer: Celina Carvalho
Production Manager: Jonathan Lopes

Library of Congress Cataloging-in-Publication Data
Niffenegger, Audrey.
The three incestuous sisters / Audrey Niffenegger
p. cm.
ISBN 0-8109-5927-5
1. Sisters—Fiction. I. Title.

PS3564.I362T48 2005
813'.54—dc22
2004023846

Printed and bound in China
10 9 8 7 6 5 4 3 2

Harry N. Abrams, Inc.
100 Fifth Avenue
New York, NY 10011
www.abramsbooks.com

Abrams is a subsidiary of

LA MARTINIÈRE
GROUPE

THIS BOOK IS DEDICATED WITH LOVE TO
MY SISTERS,
BETH AND JONELLE NIFFENEGGER

Bettine

There once were three sisters:
Clothilde, Ophile, and Bettine.

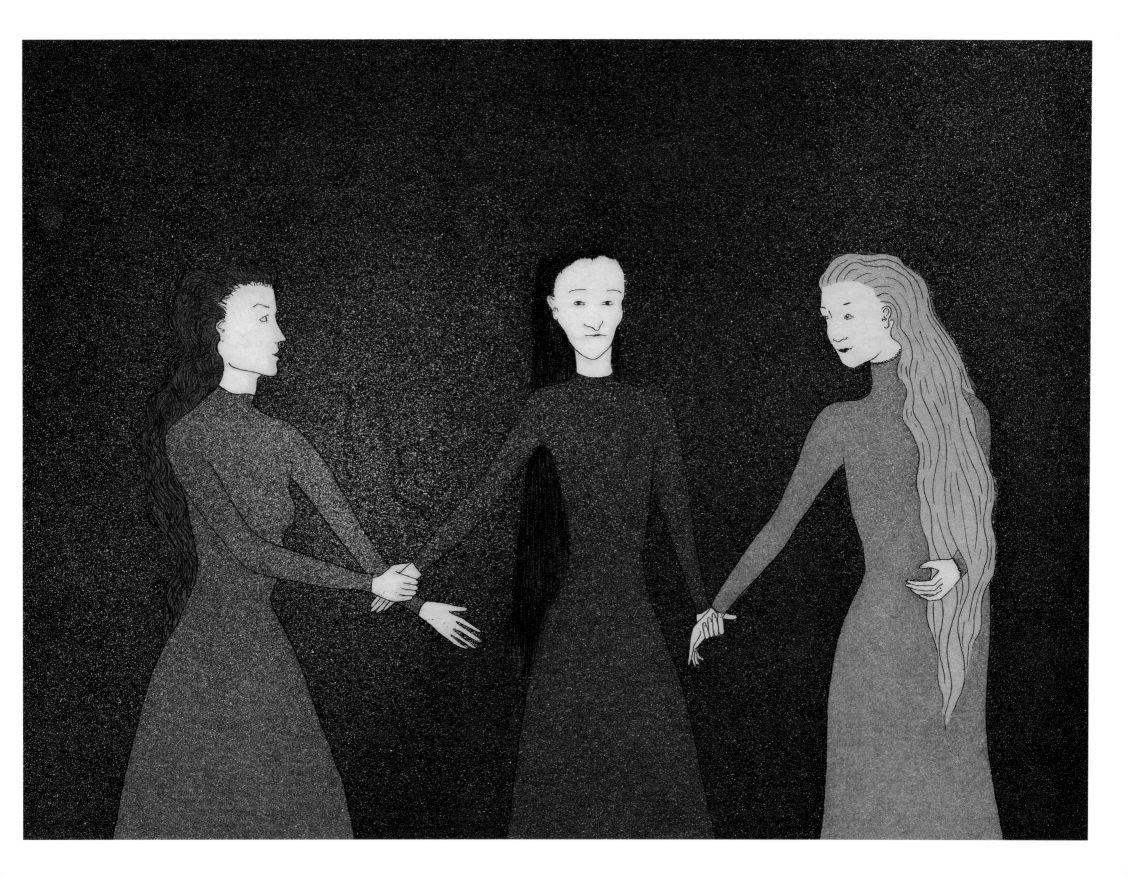

They lived together in
a lonely house by the sea,
near the lighthouse,
miles away from the city.

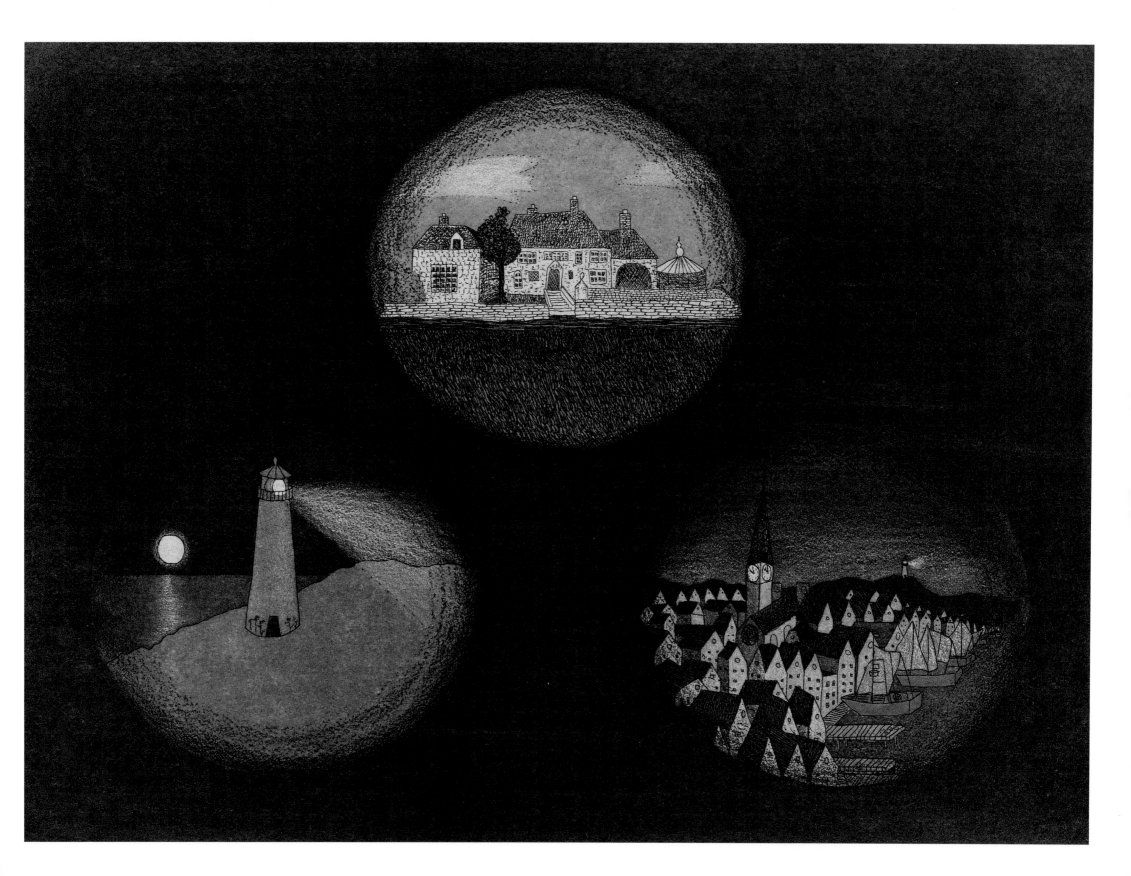

Bettine, the youngest, had blond hair and was considered the prettiest sister. Ophile, the eldest, had blue hair and was often thought to be the smartest sister. And Clothilde, who had red hair, was in the middle, and was the most talented sister.

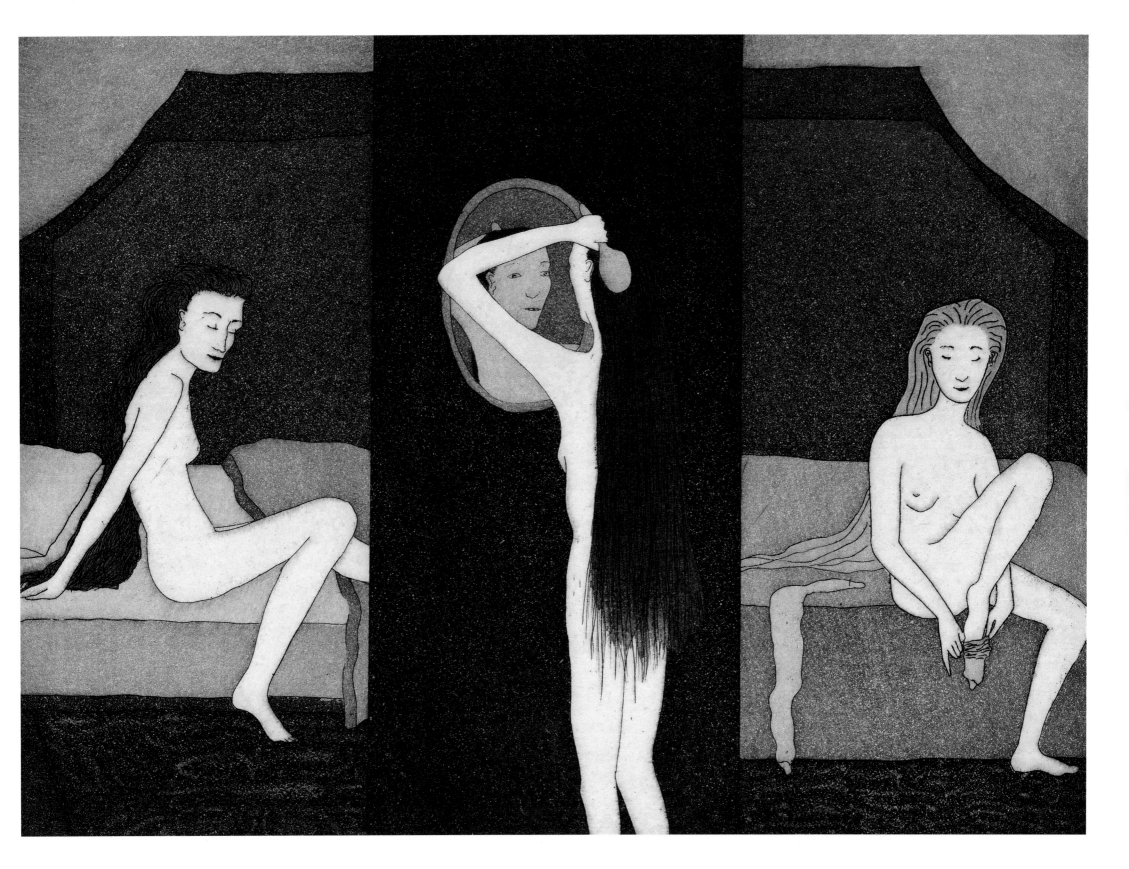

As the curtain slowly rises, the story
begins with a gathering storm.

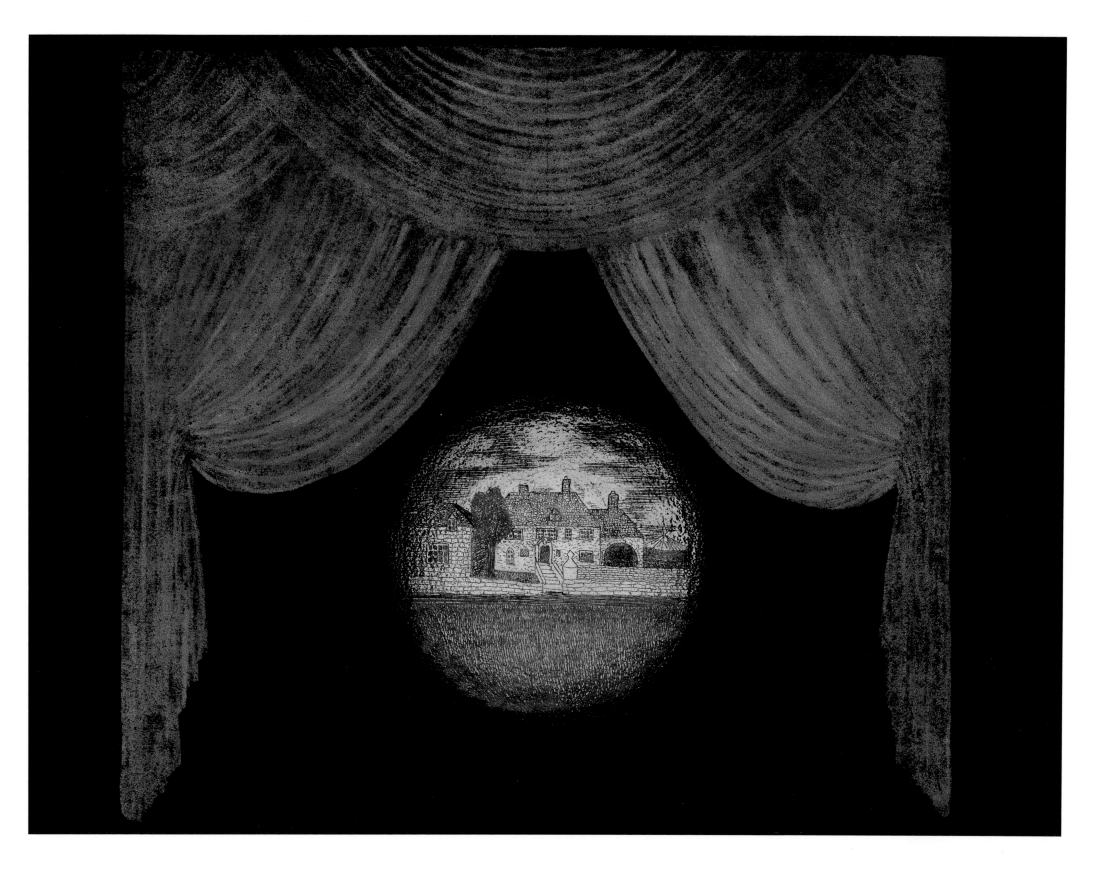

The house must be shut
against the coming storm;
Bettine moves from window
to window, closing them all
against the water that is about
to come but leaving the door
open to admit the cool breeze.

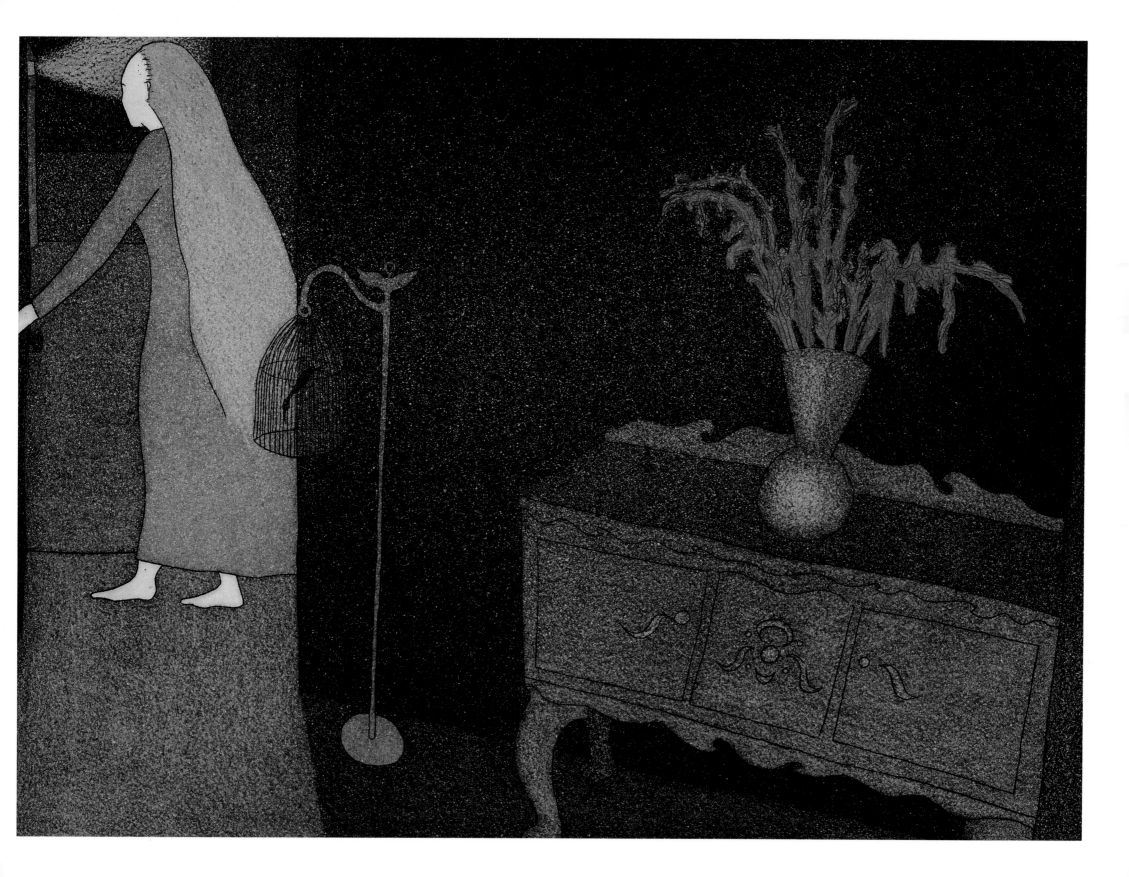

The death of the old
Lighthouse Keeper
by lightning:

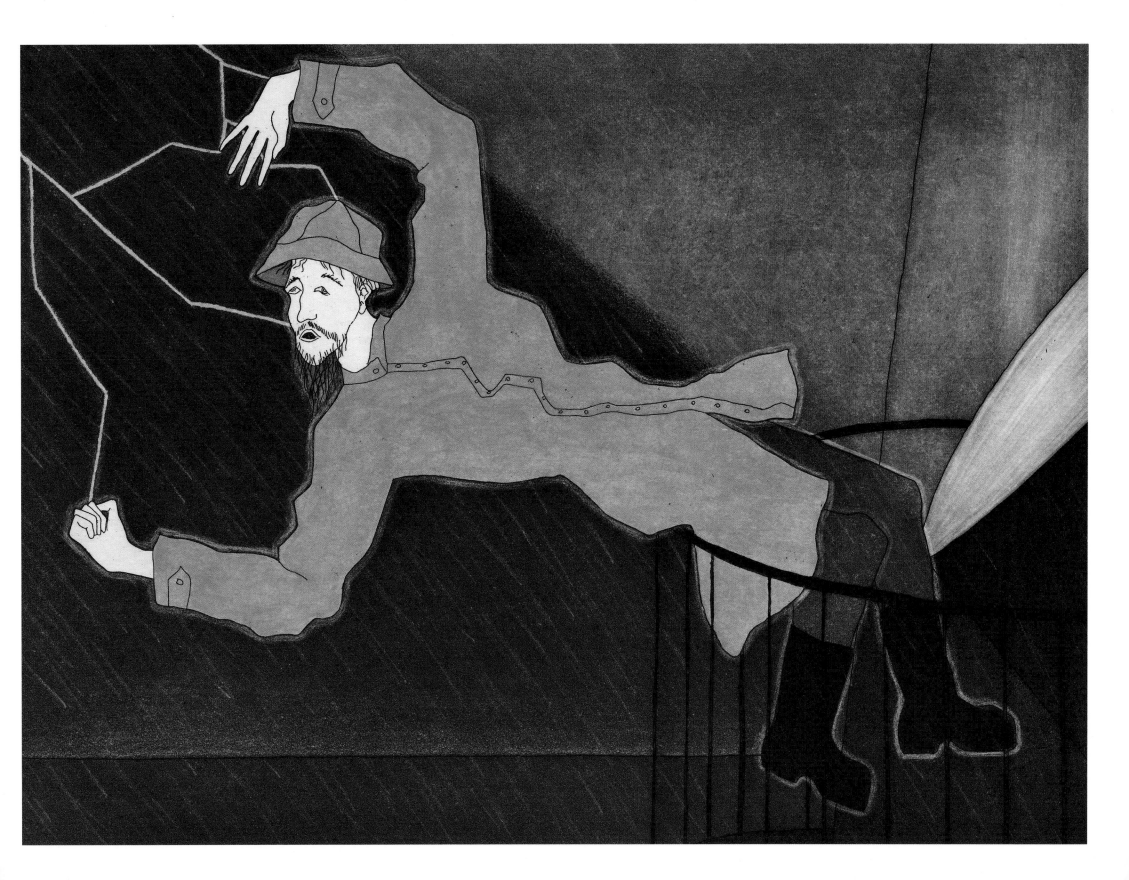

Oh! How terrible, how very sad;
poor old man, we must
send for his son.

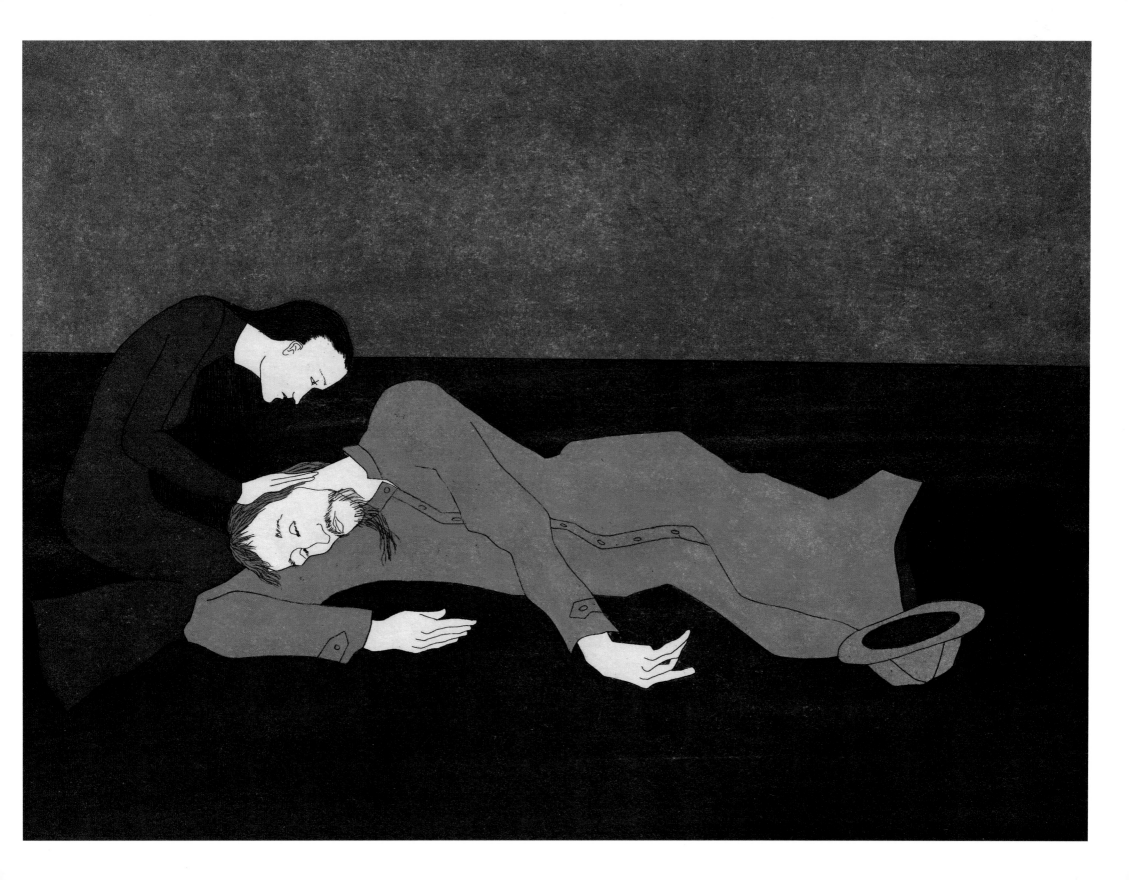

Enter Paris,
the Lighthouse
Keeper's son.

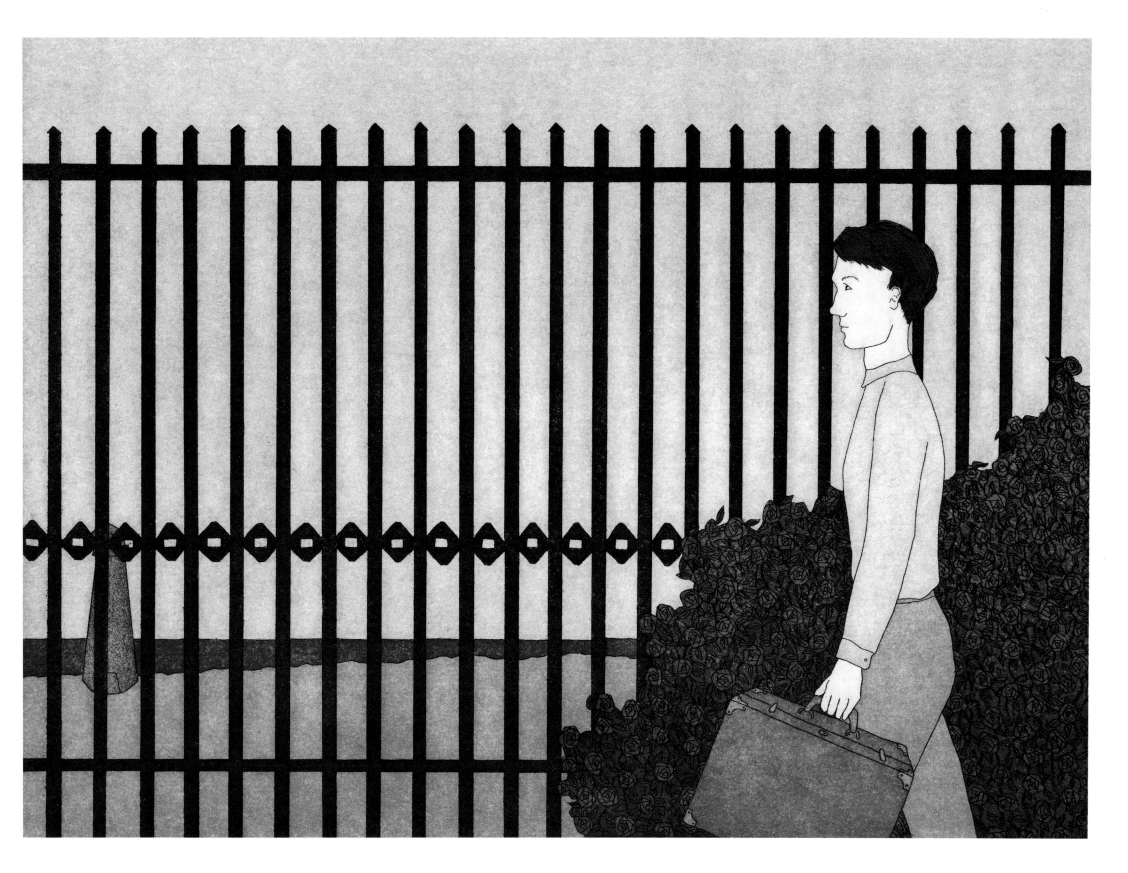

Bad luck: Bettine.

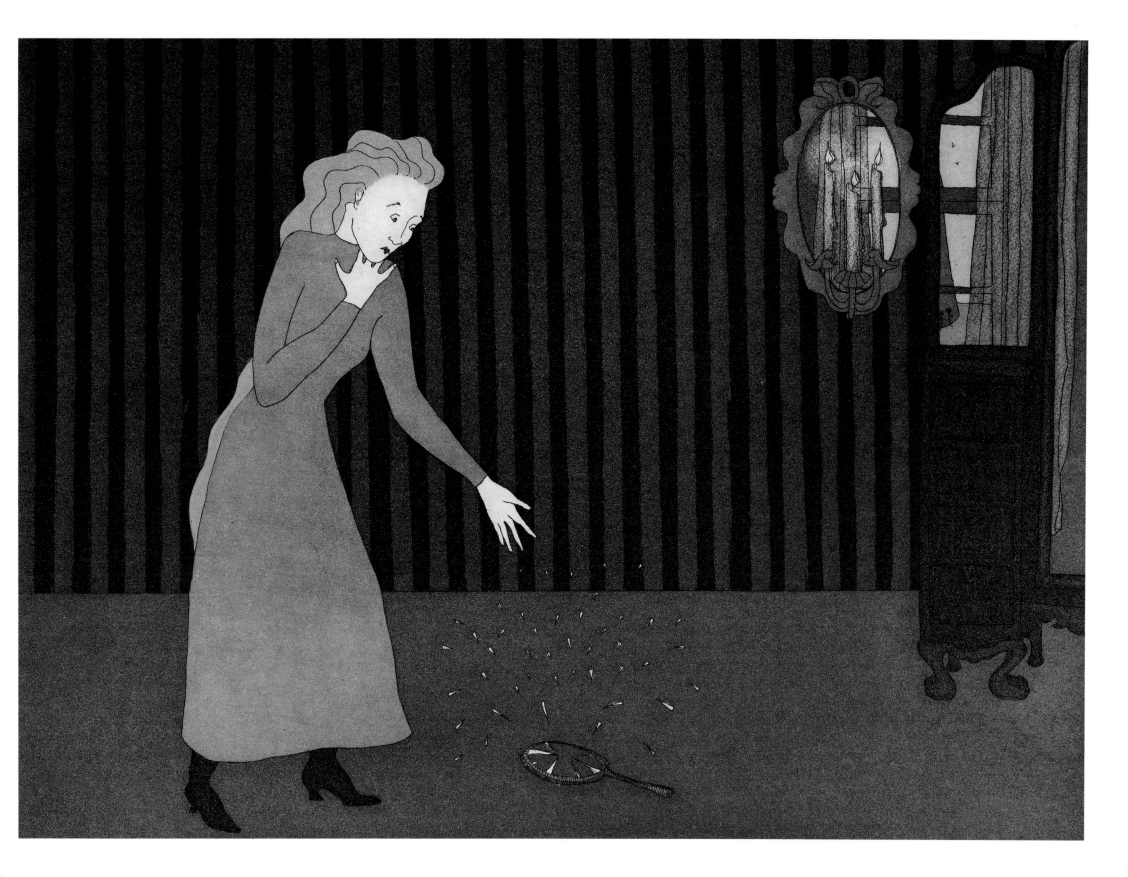

Bad luck: Ophile.

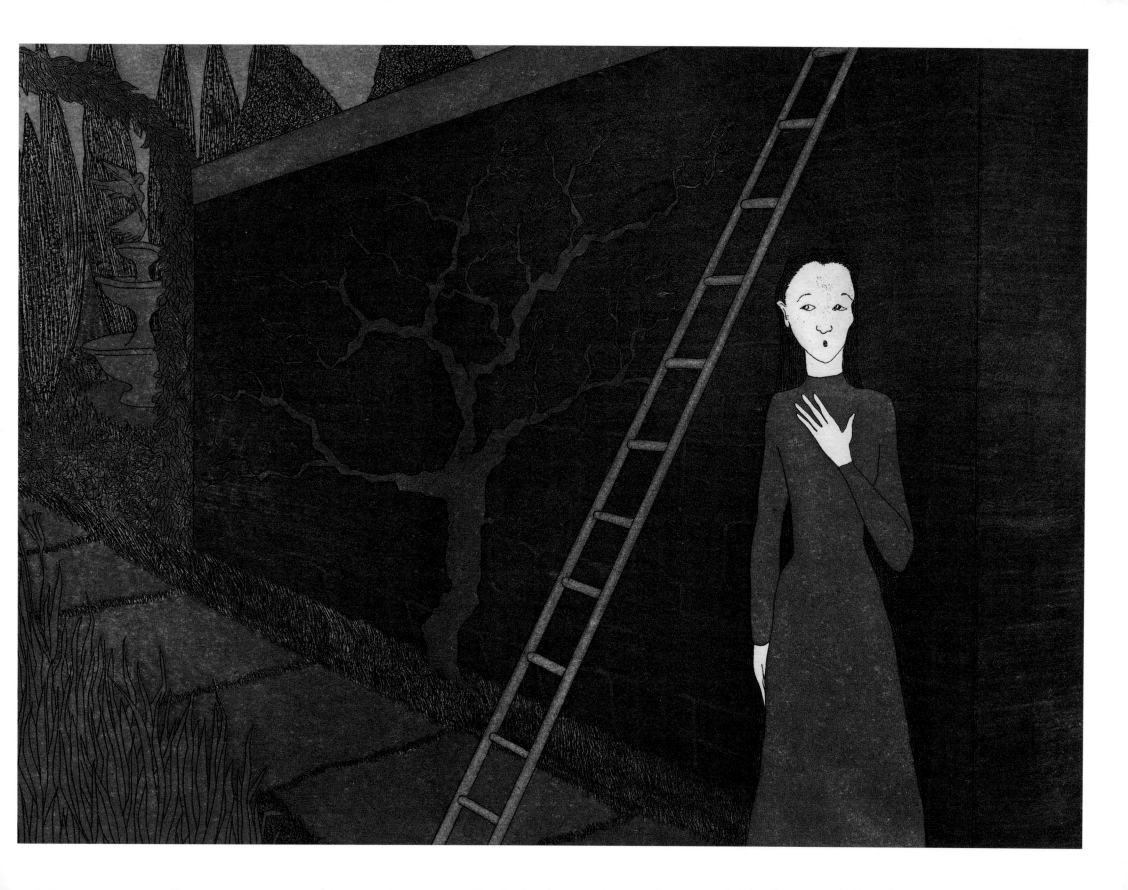

Bad luck: Clothilde.

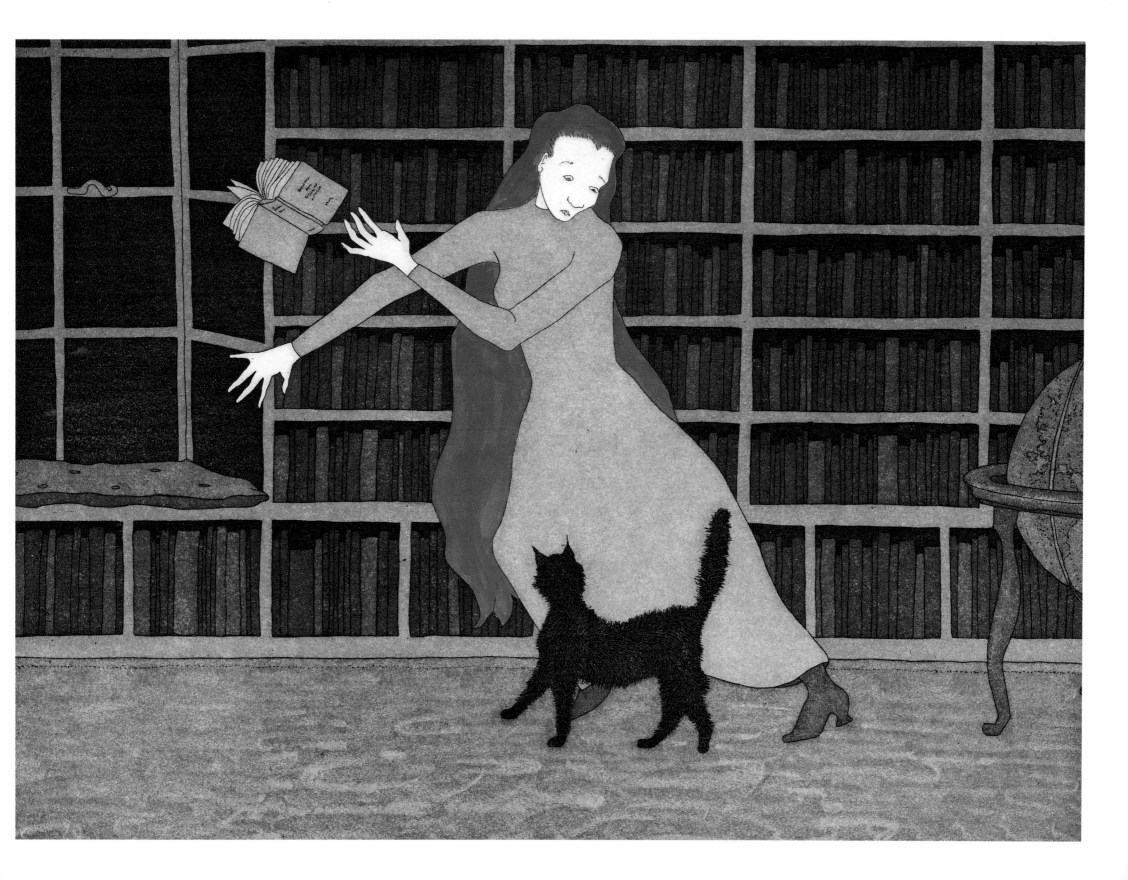

A few days later;
Clothilde practices
levitation at breakfast.

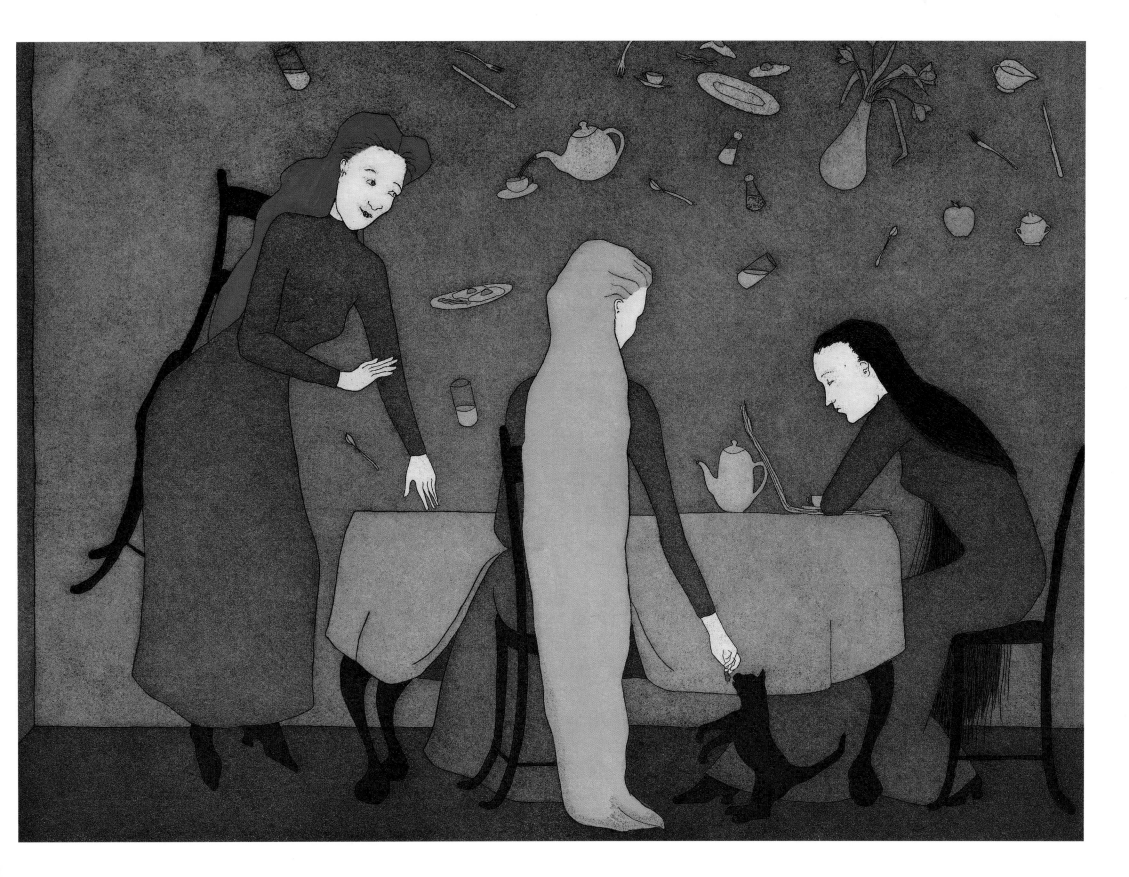

*P*aris's choice:

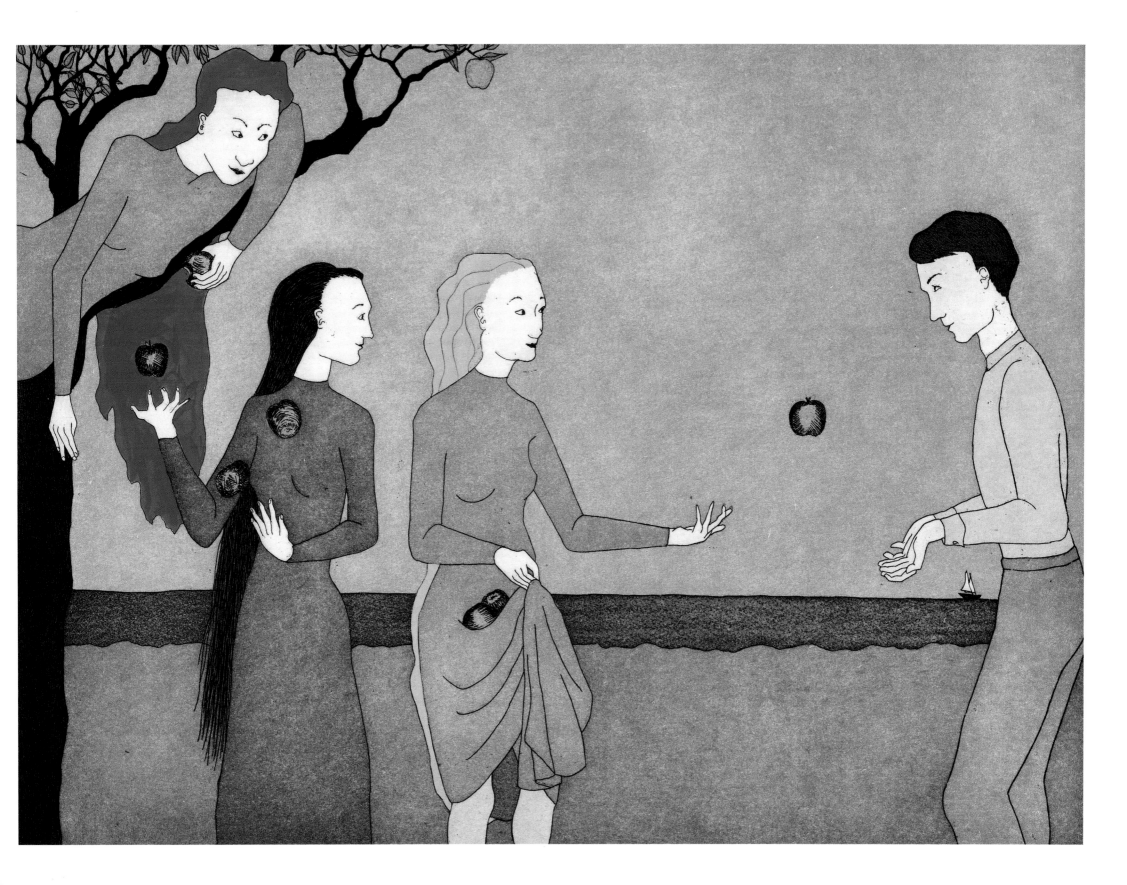

The courtship of
Paris and Bettine.

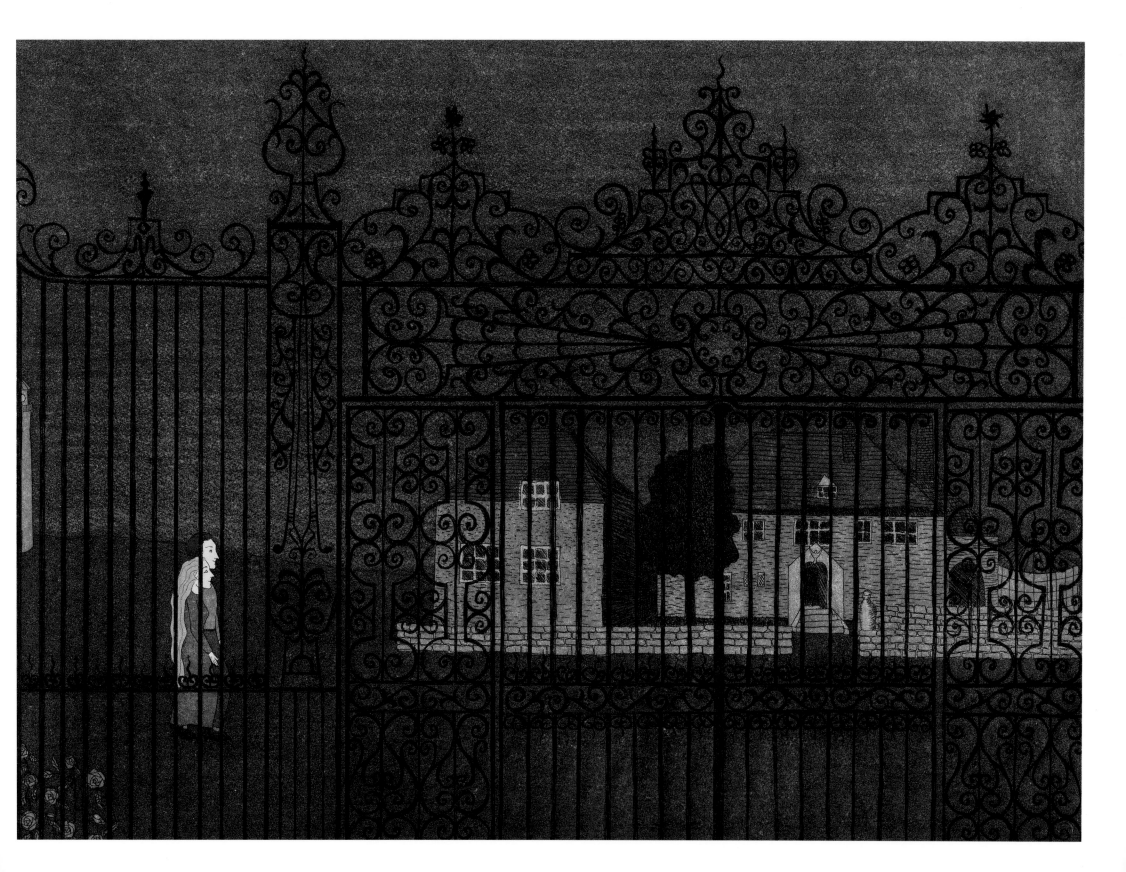

*T*ea in the old nursery.

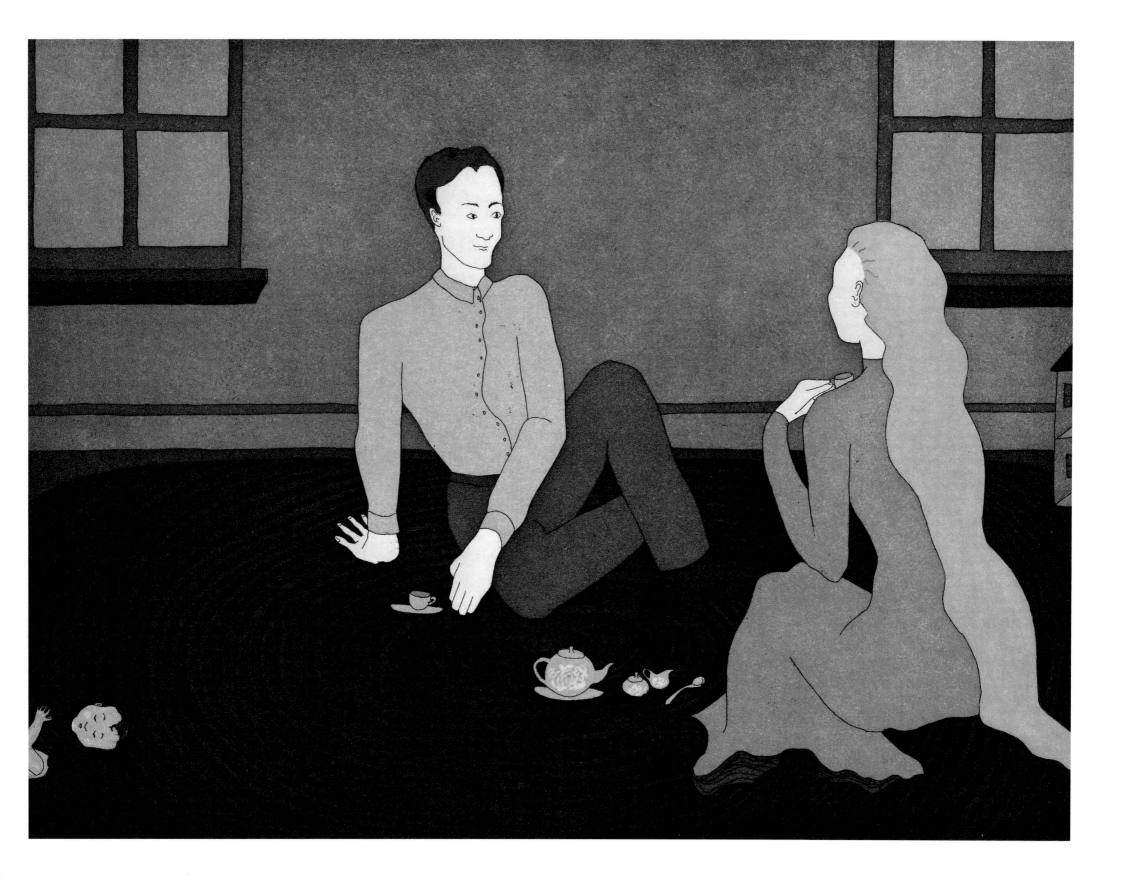

Ophile finds herself
watching them secretly, and
is jealous and ashamed.

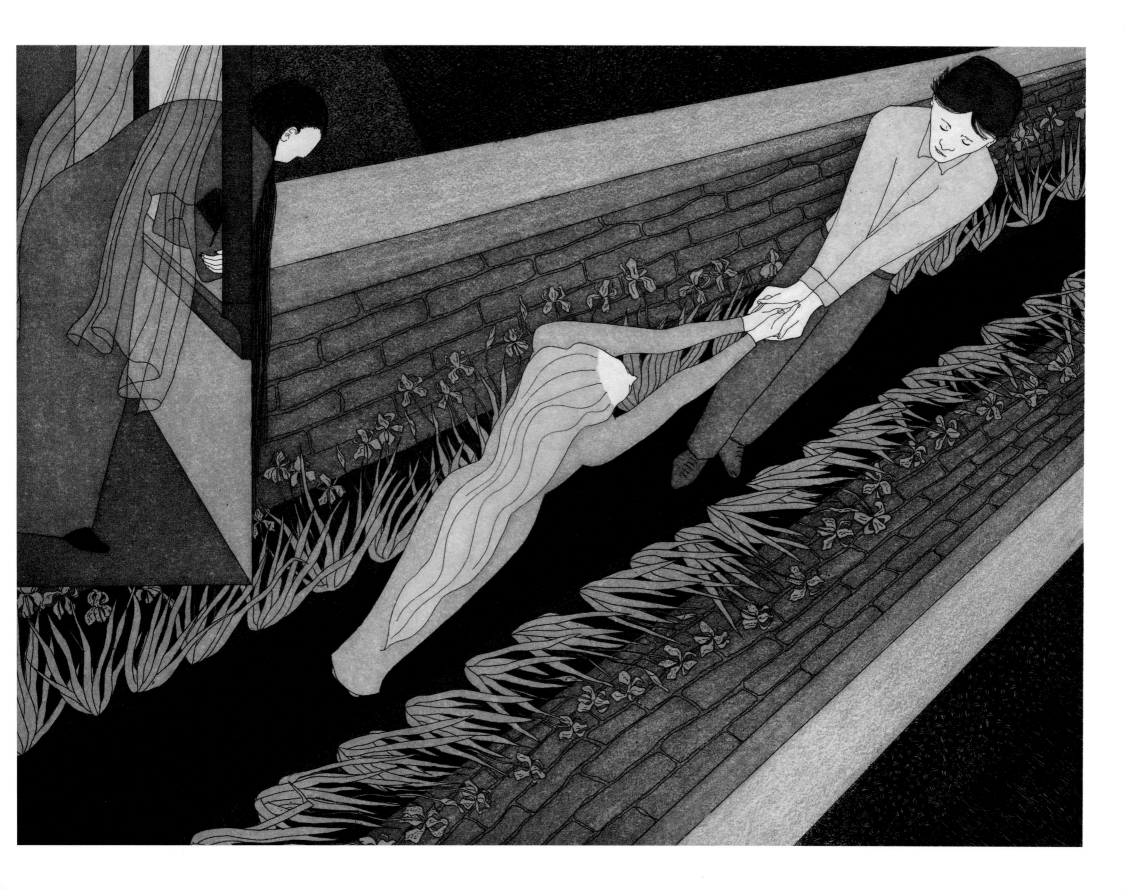

*C*lothilde in her
own little world:

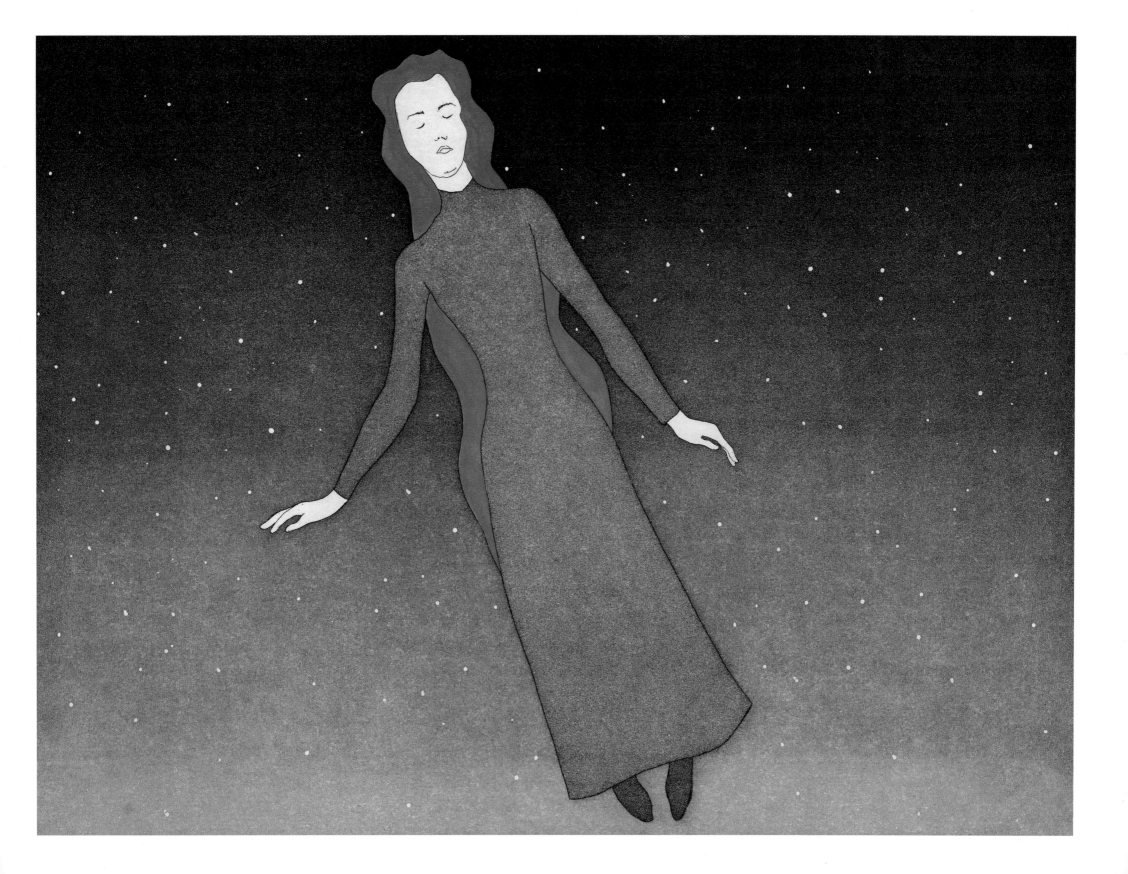

Clothilde *knows* that the cause of headache is birds using pieces of her hair to build their nests. Therefore, she saves all her hair in jars hidden in her closet. Despite this, she continues to suffer.

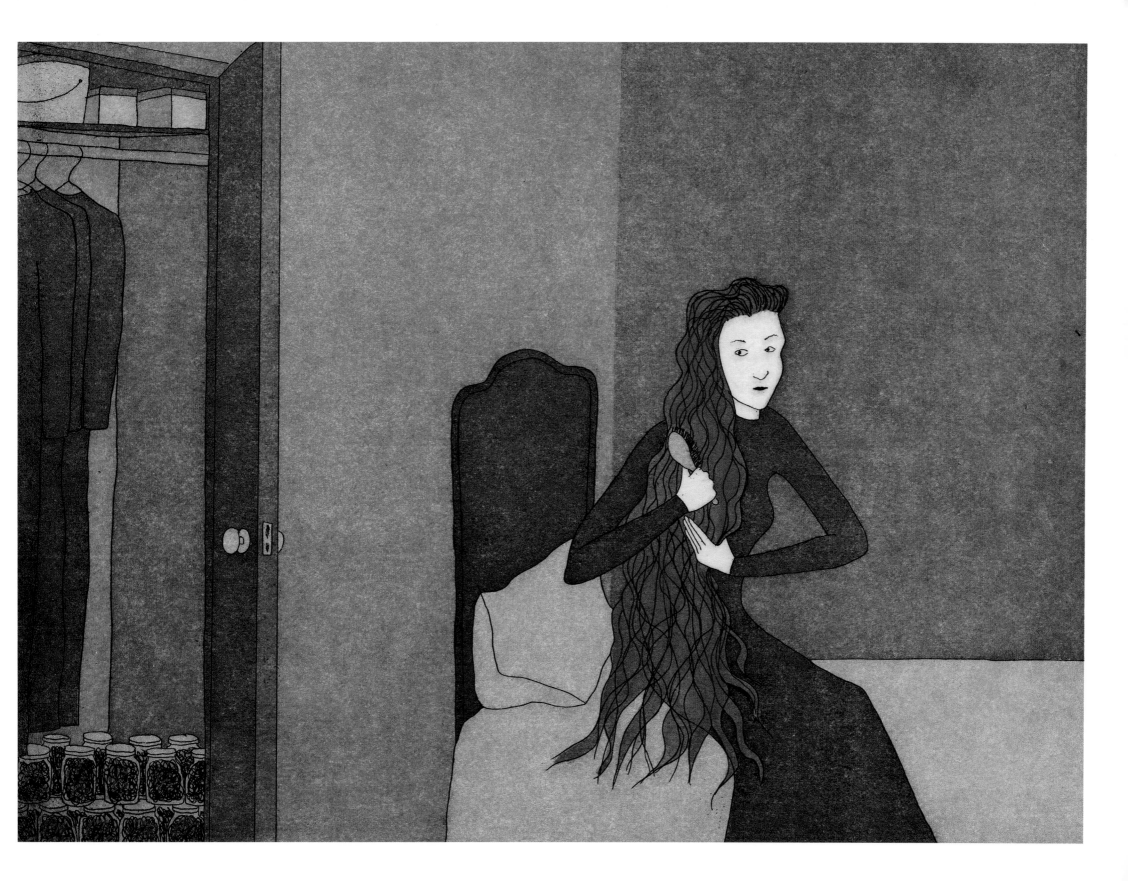

*C*lothilde's headache:

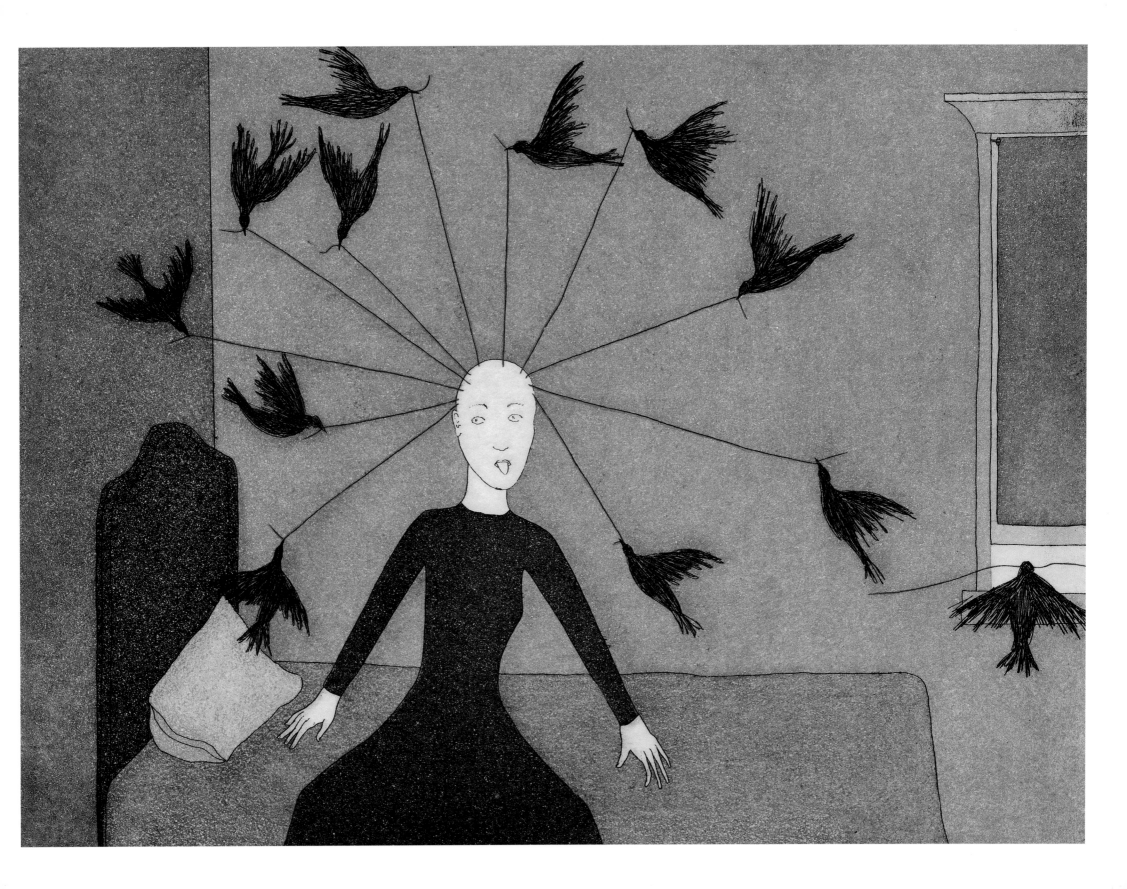

One hair left and
one bird waiting.

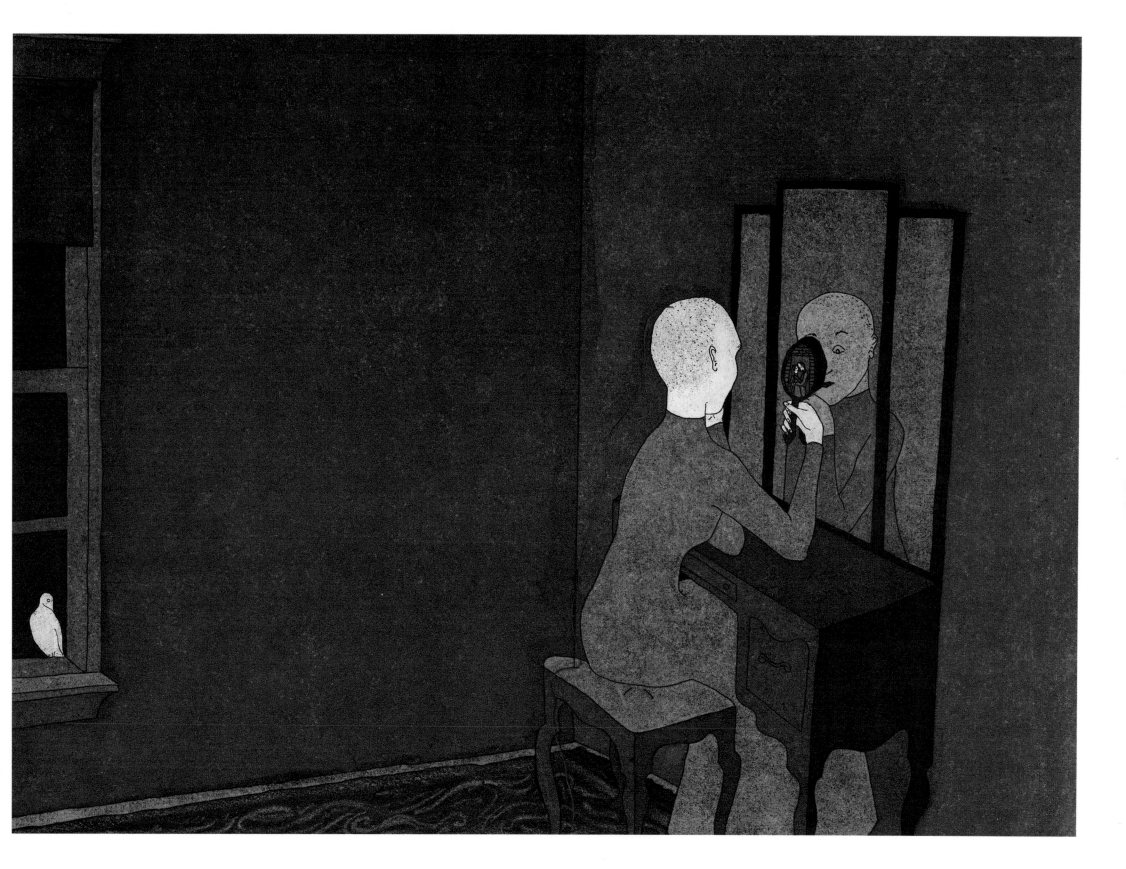

Another lovely day.

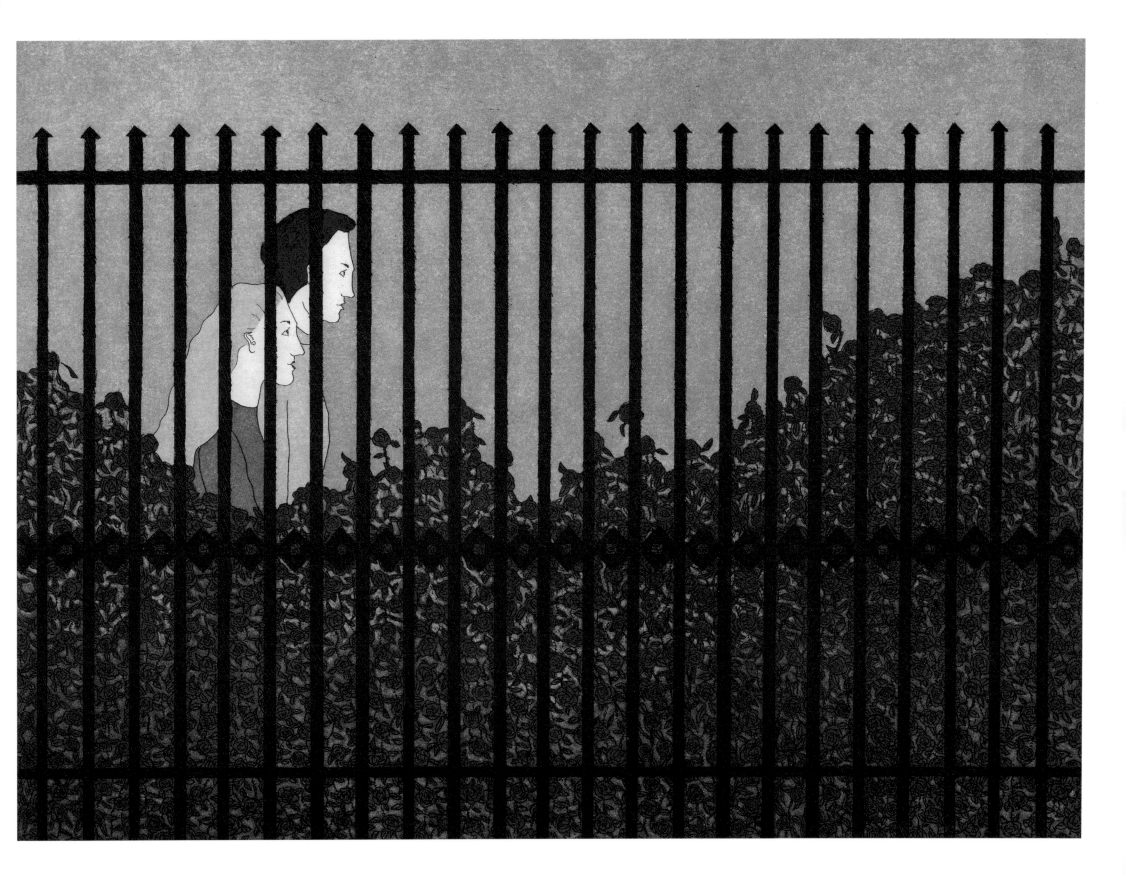

A kiss.

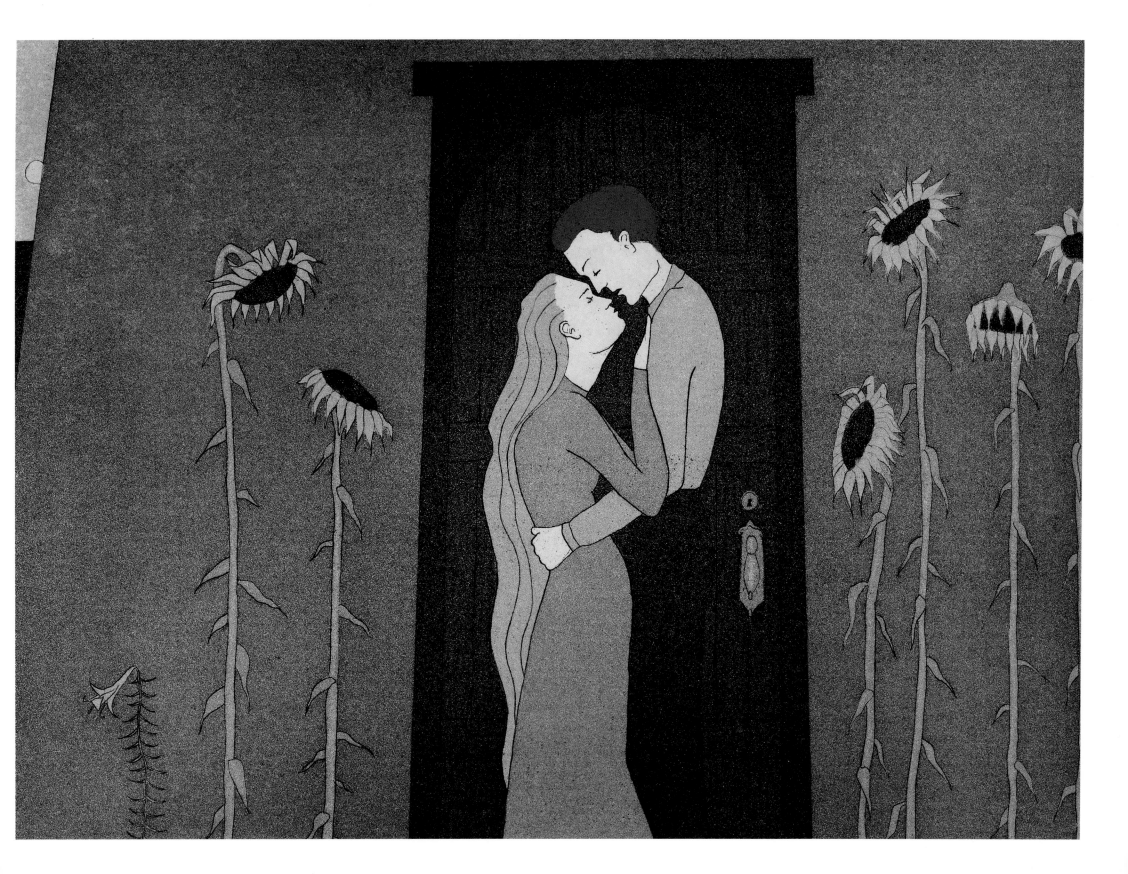

Ophile, miserable and sorry.

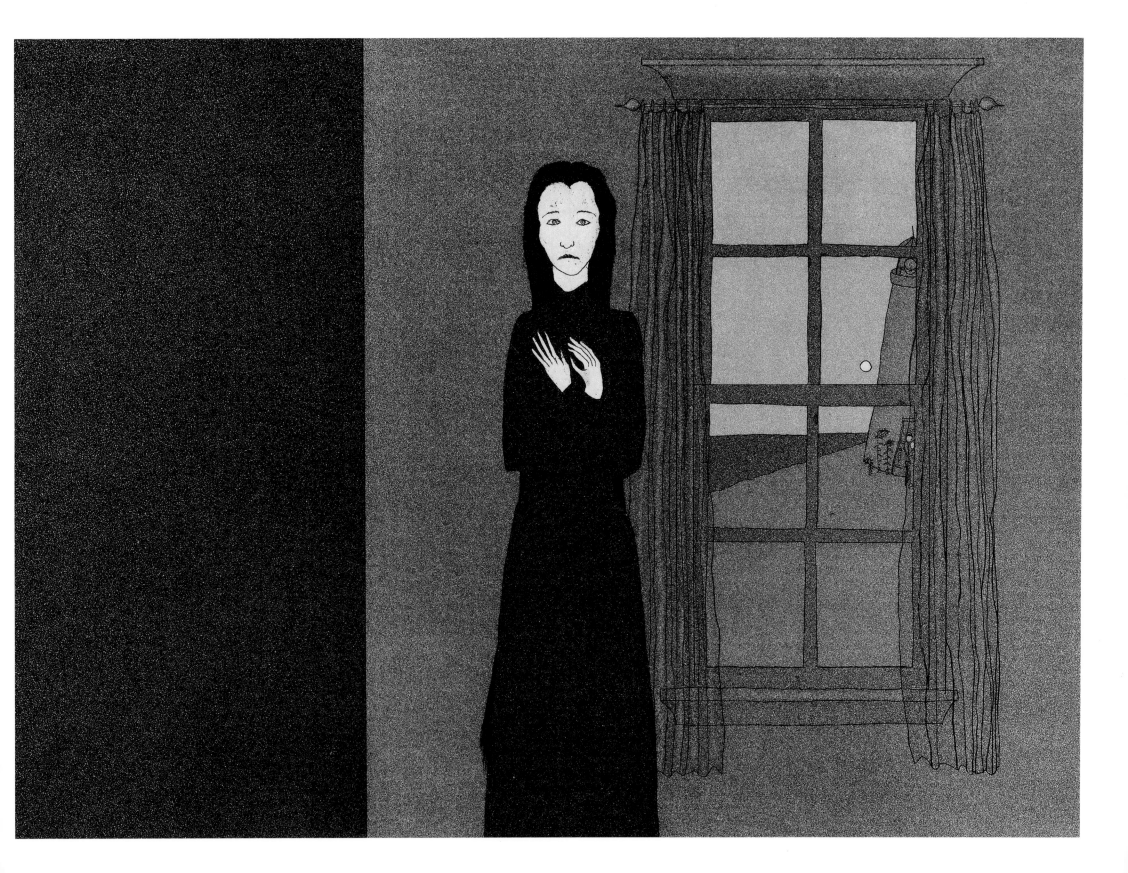

Being cruel to Bettine.

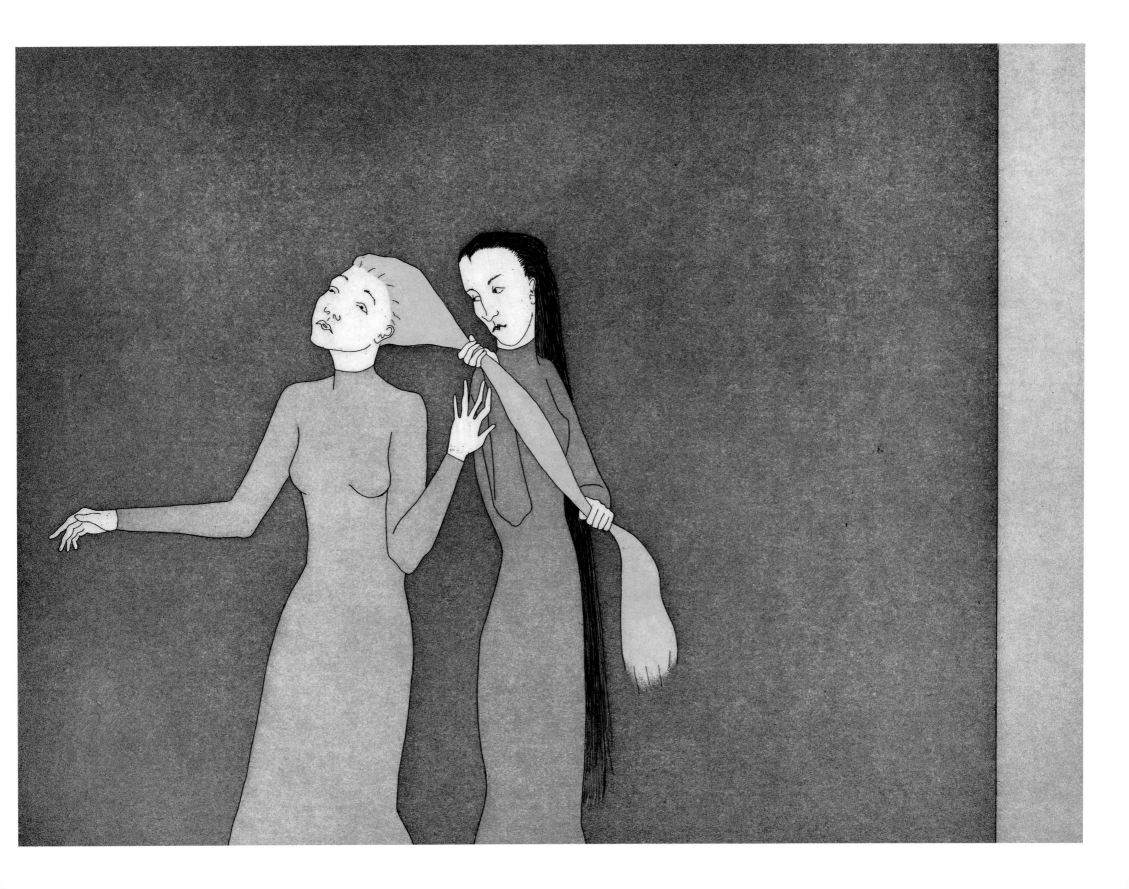

*P*aris intercedes.

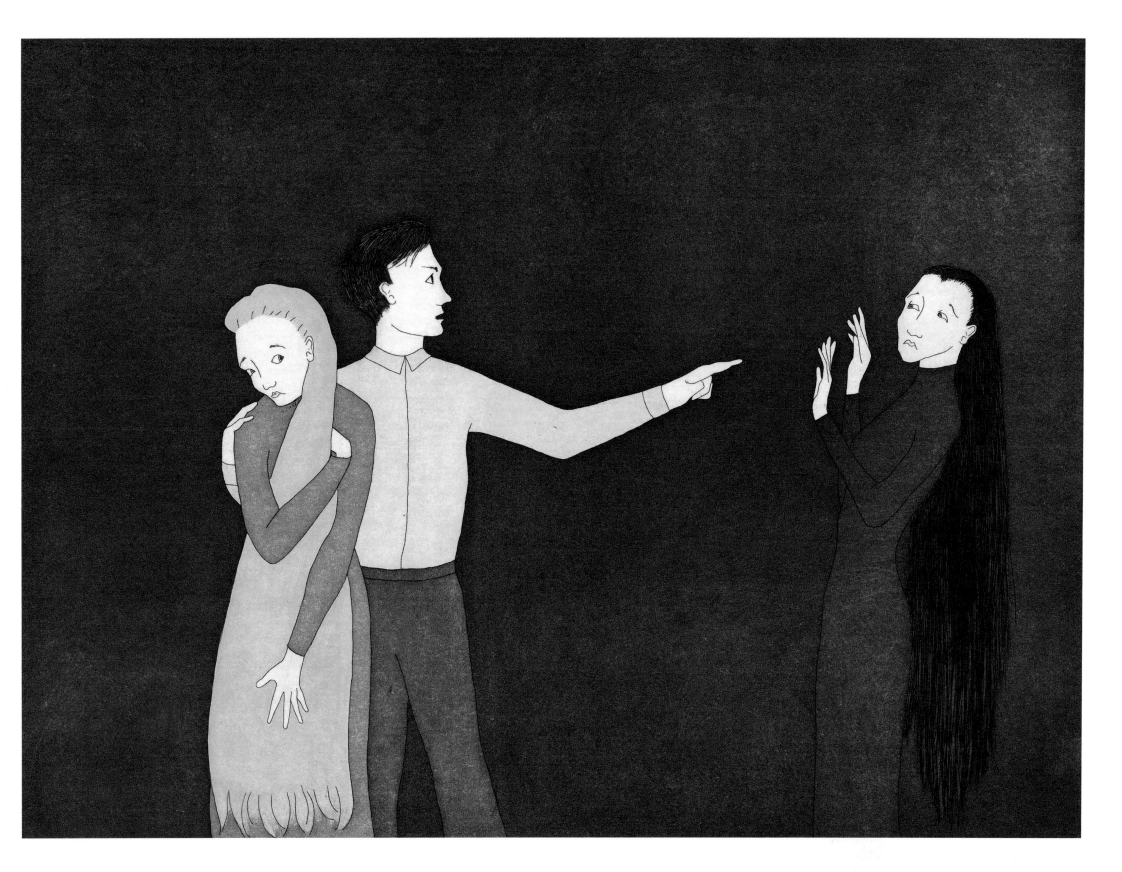

Ophile, miserable,
small, and alone.

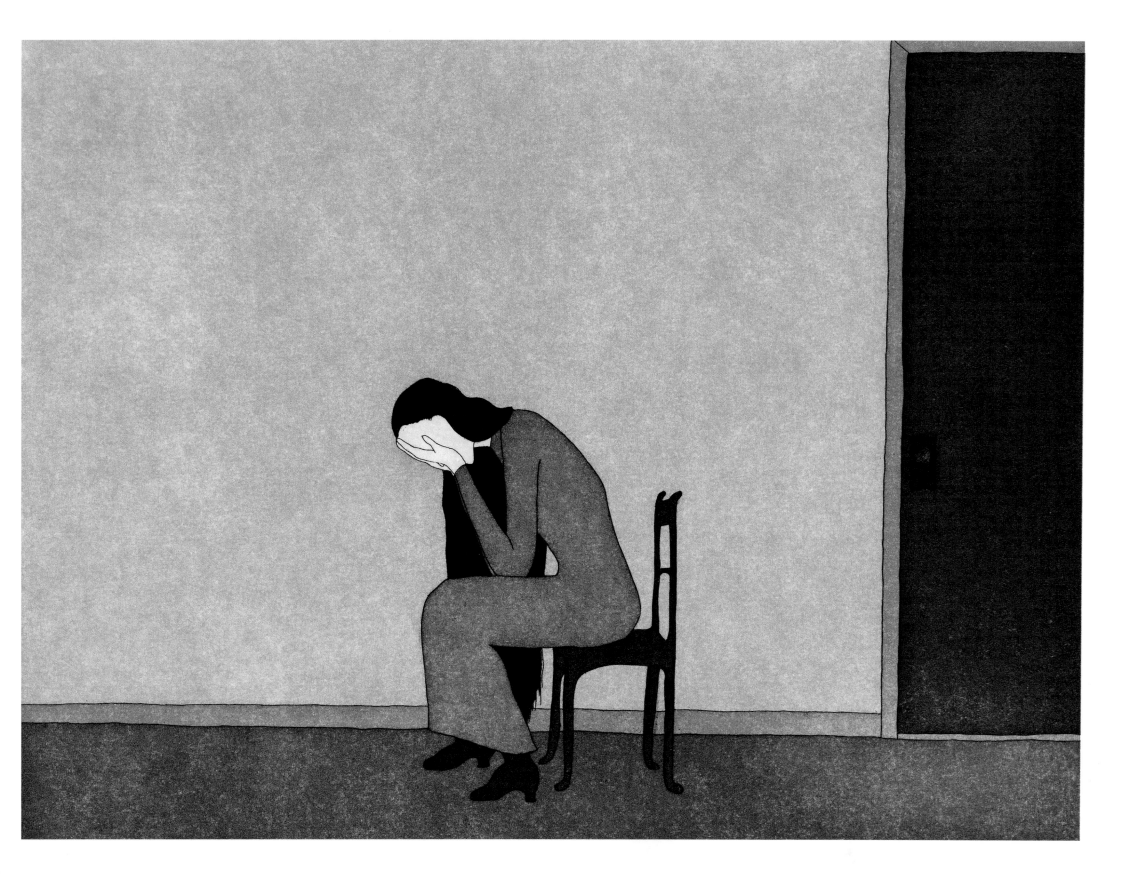

*I*n Bettine's bedroom:

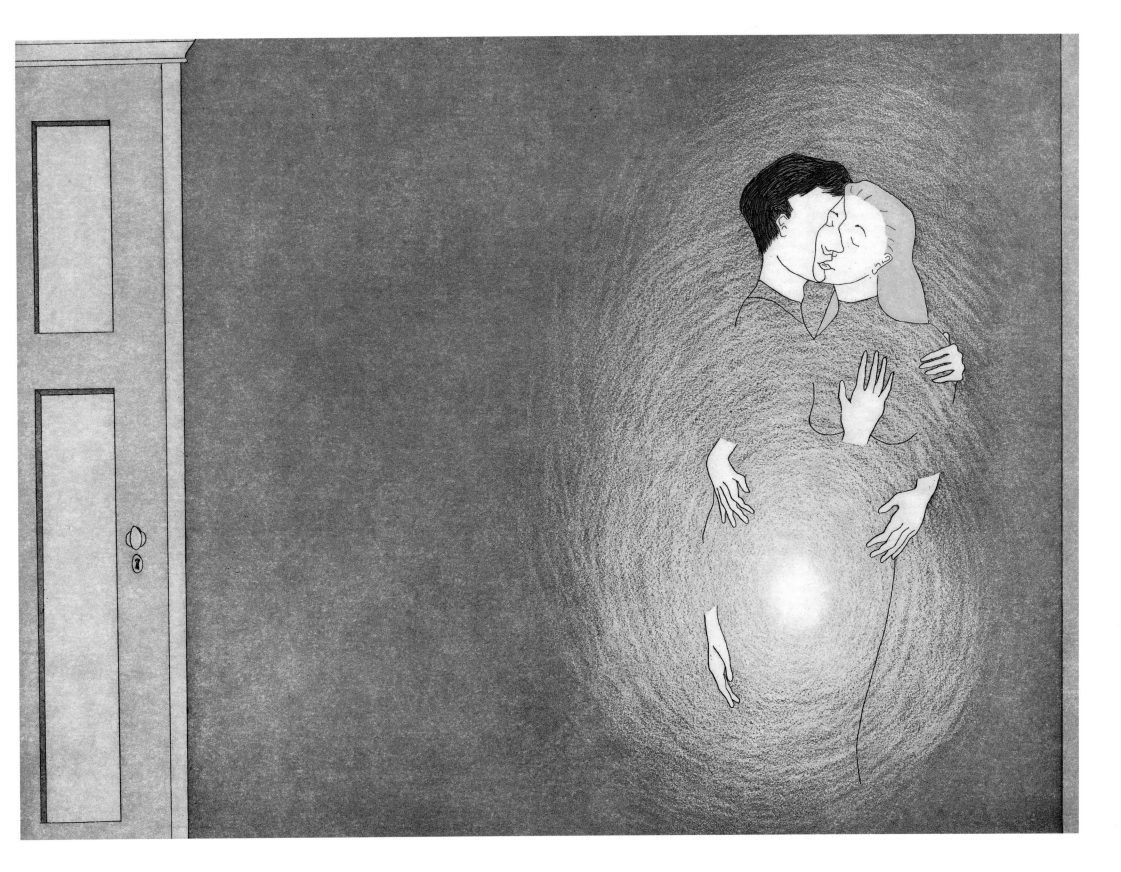

*C*lothilde, raptured.

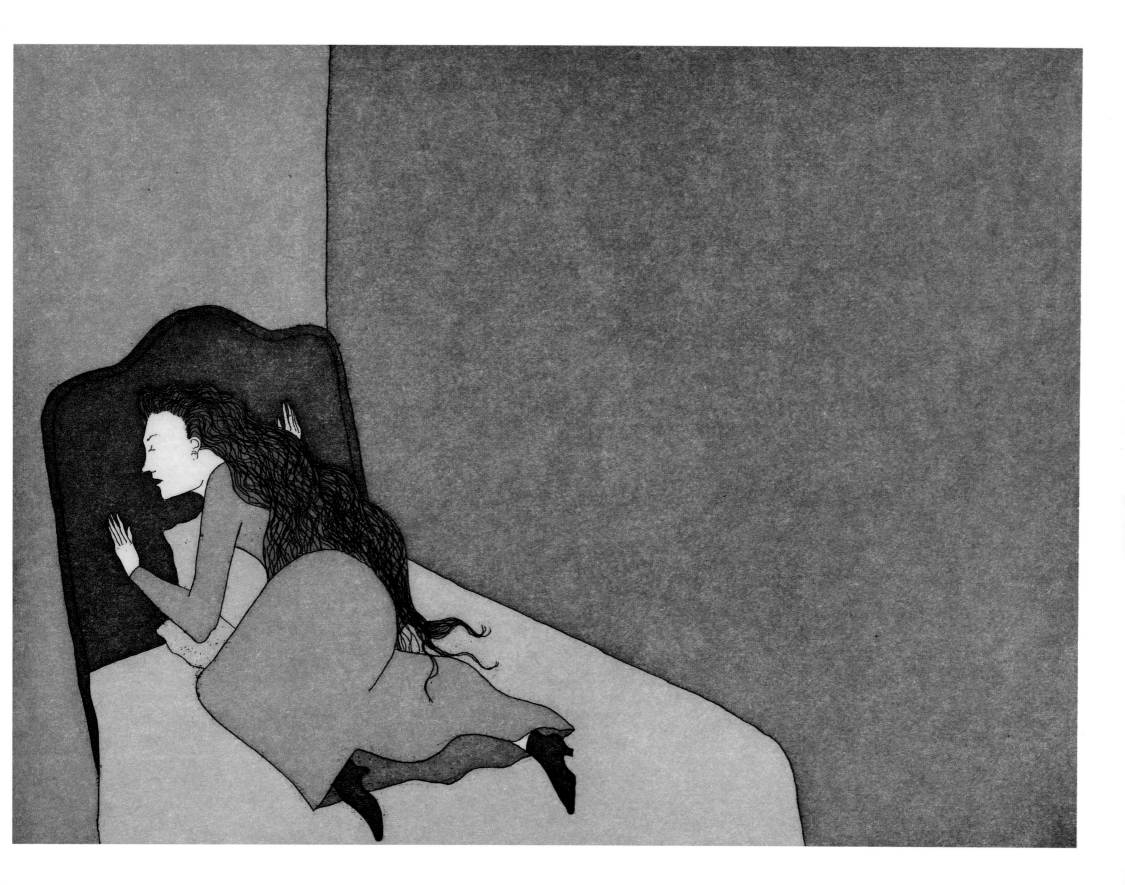

The conception:

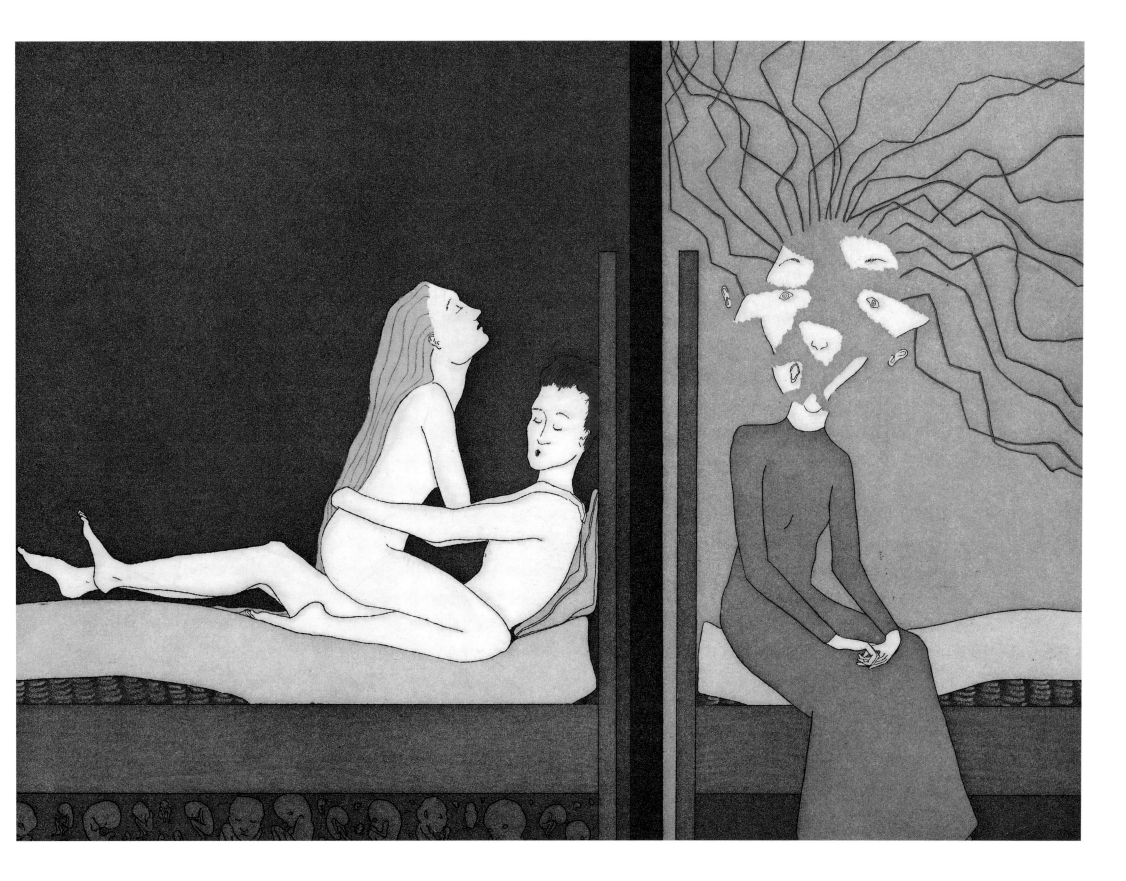

Afterward:

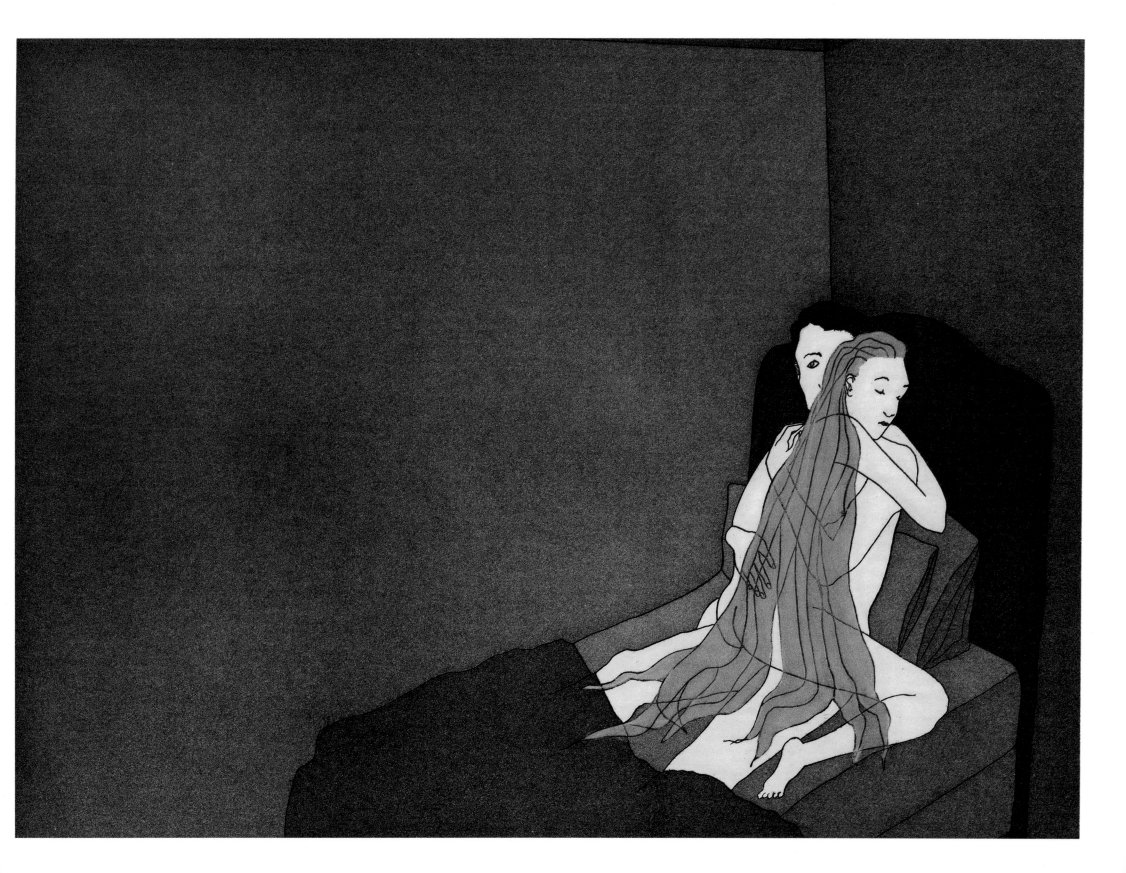

*M*any weeks later;
Clothilde and her nephew
communing late at night.

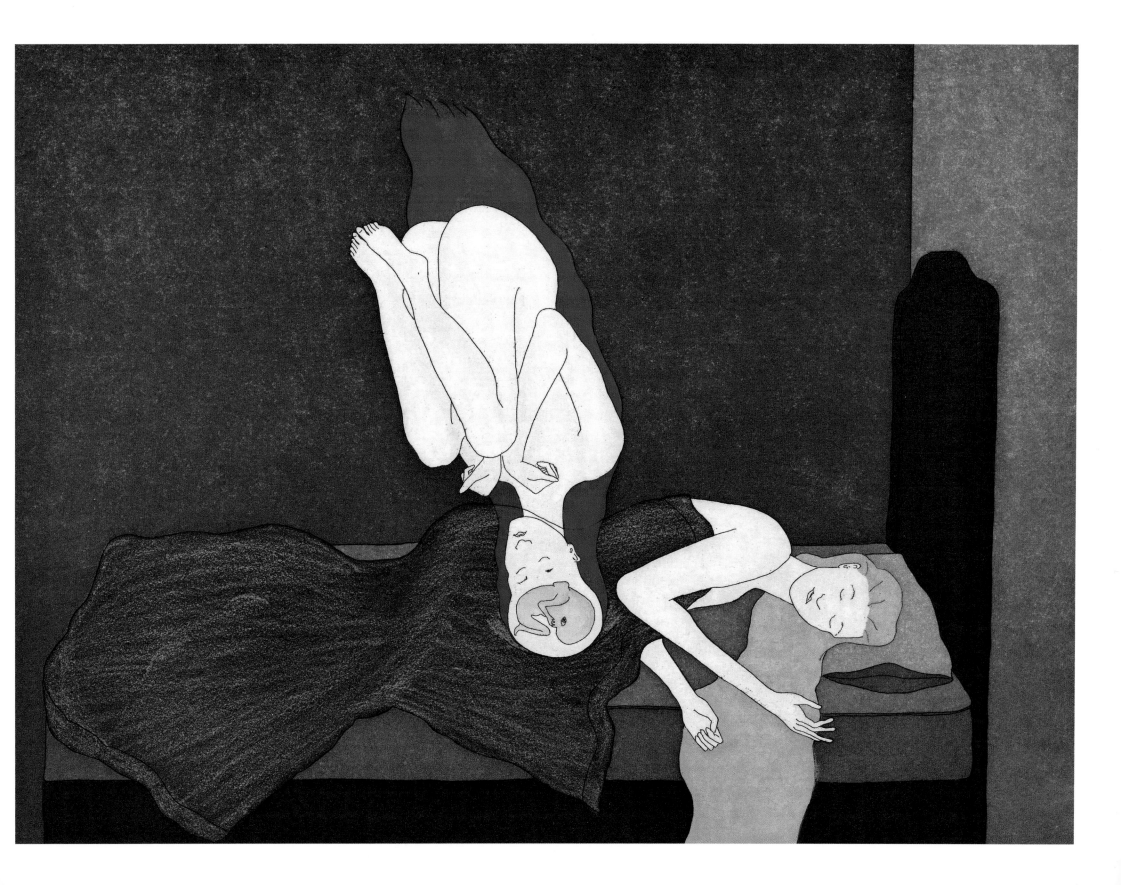

The astronomy lesson:

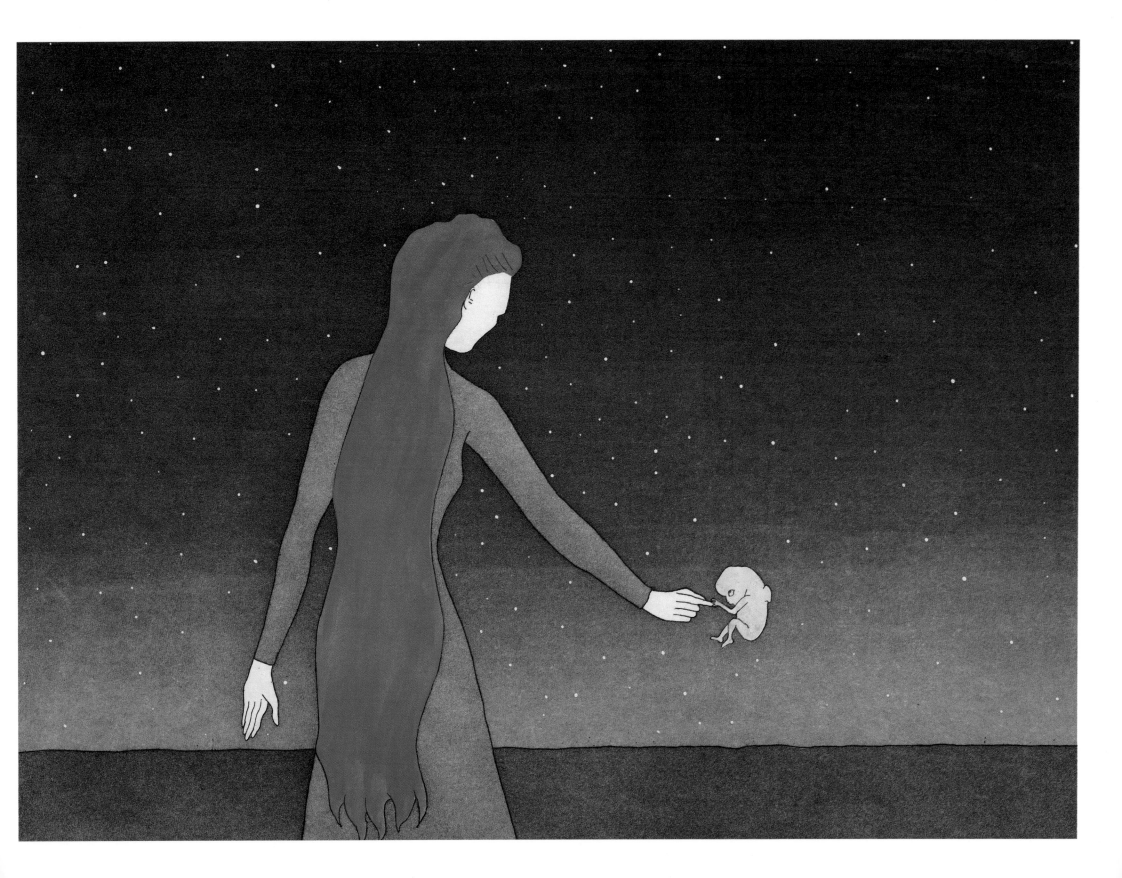

The mathematics lesson:

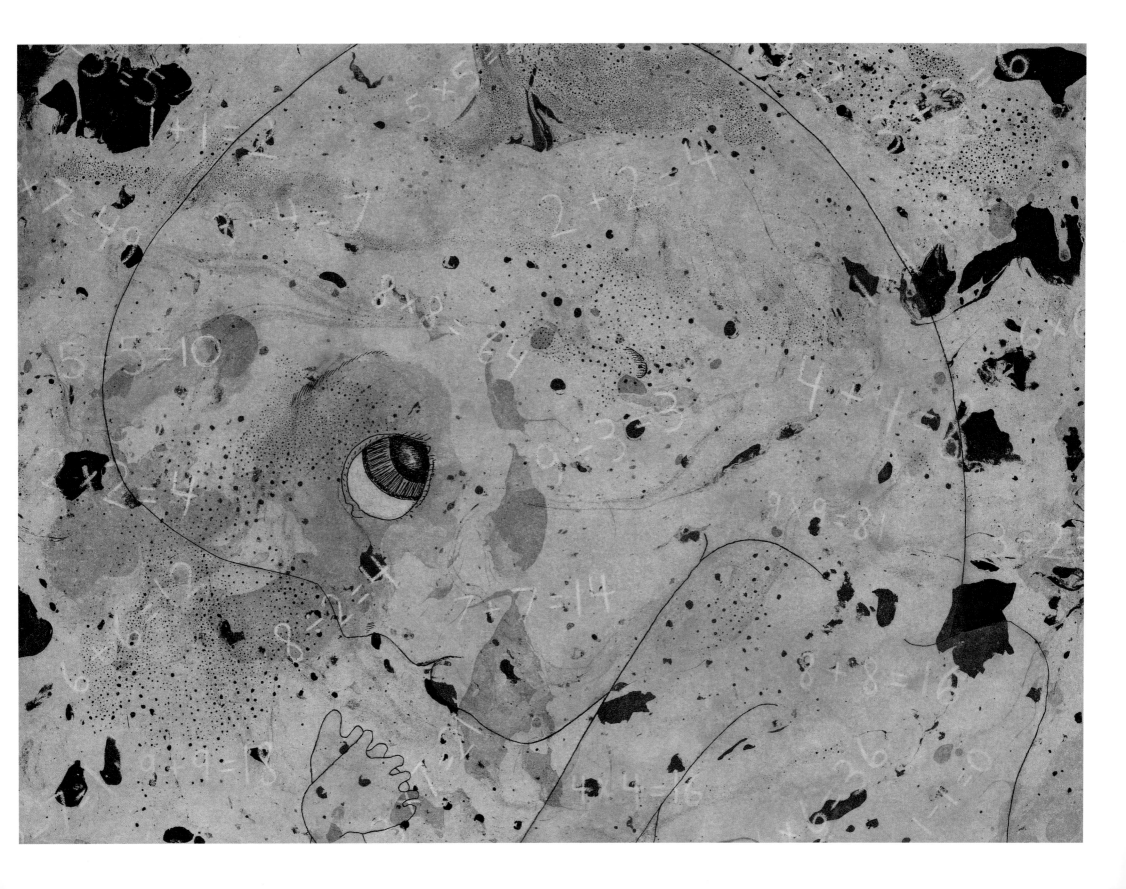

The naming of things:

The flying lesson:

When you are older, you will fly like a bird,

over the heads of all the people, above the trees

and houses, and people will think you are

an angel, or a devil; they will be afraid

of you and call you names, but your real name is

The Saint, because you are perfect, and beloved.

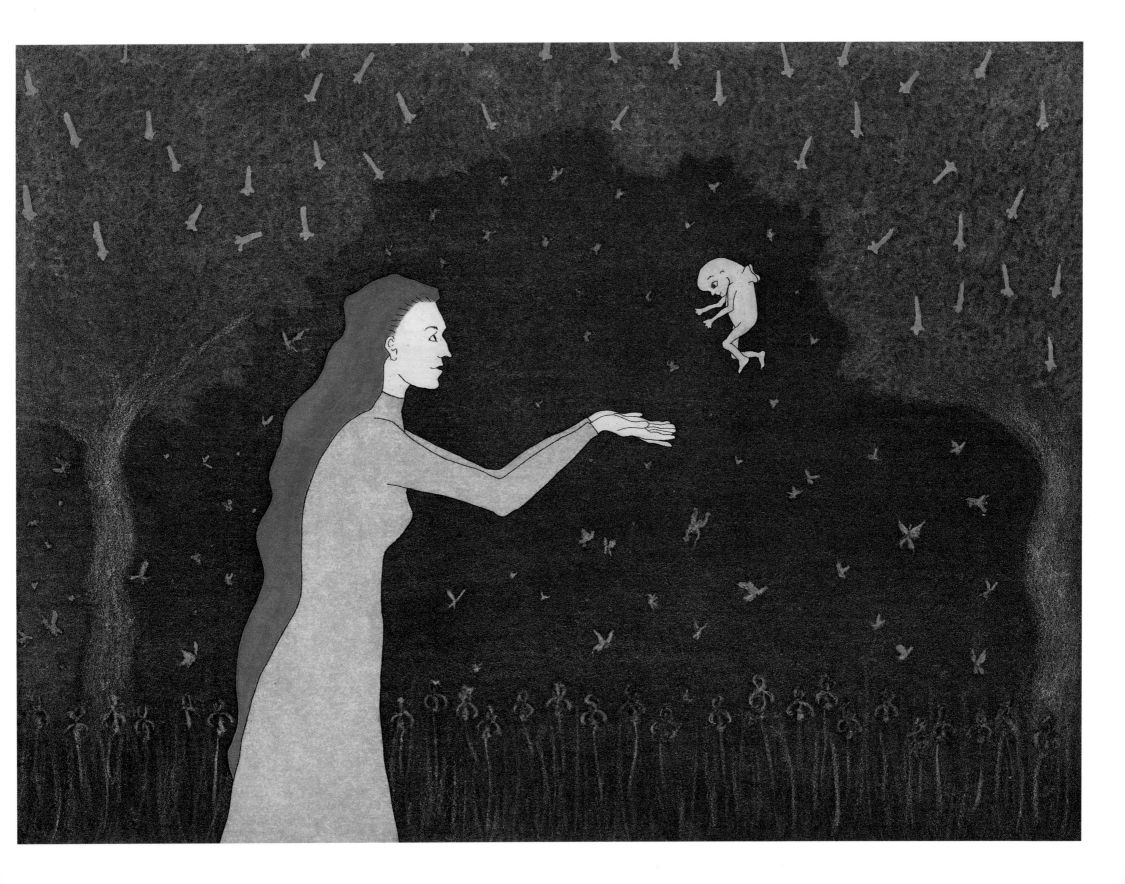

Ophile

Ophile realizes that
Bettine is pregnant.

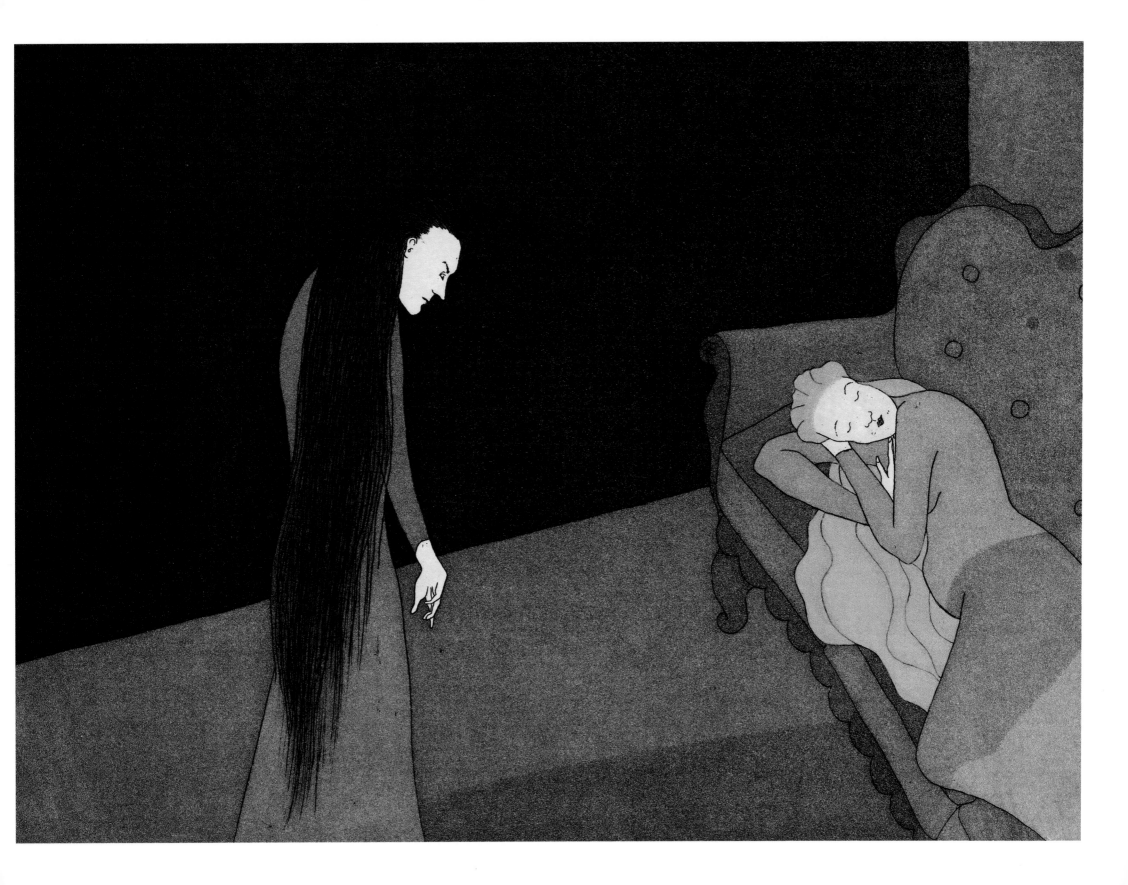

Being cruel to Bettine.

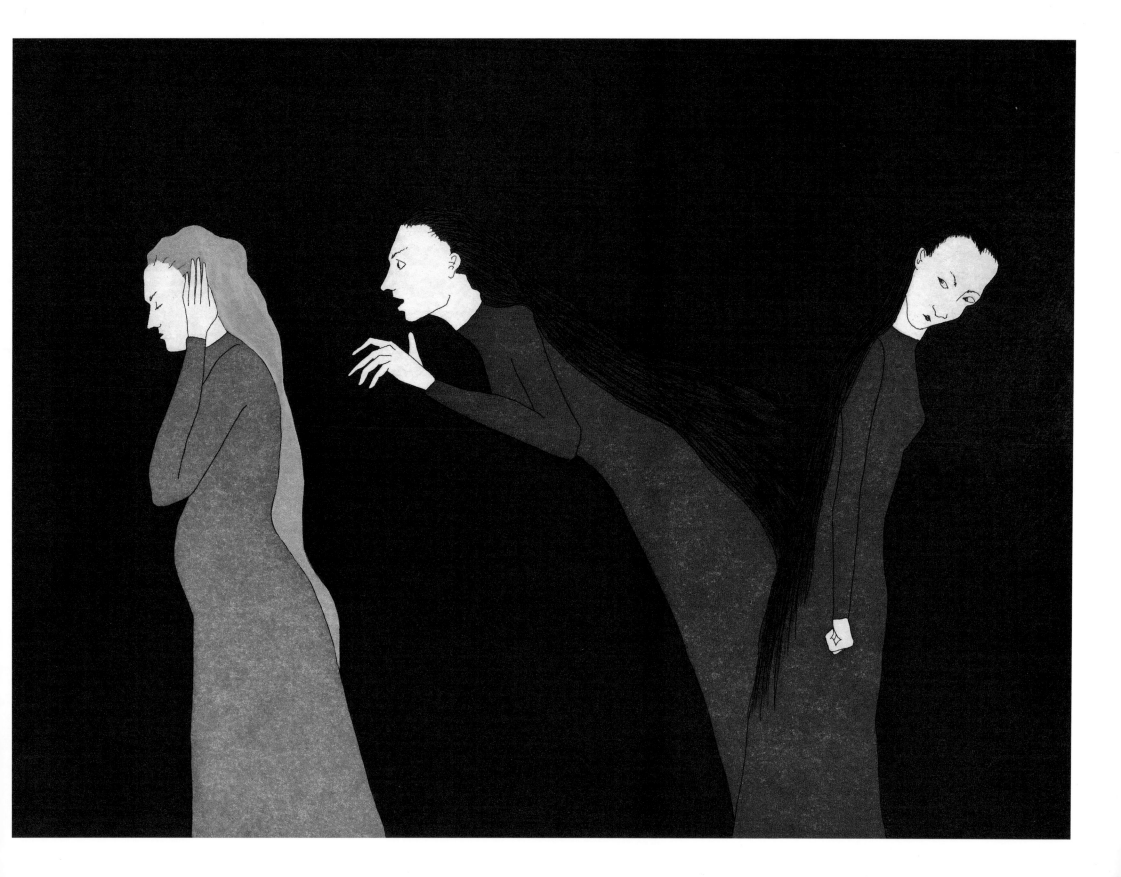

Ophile confesses her
love and is rebuffed.

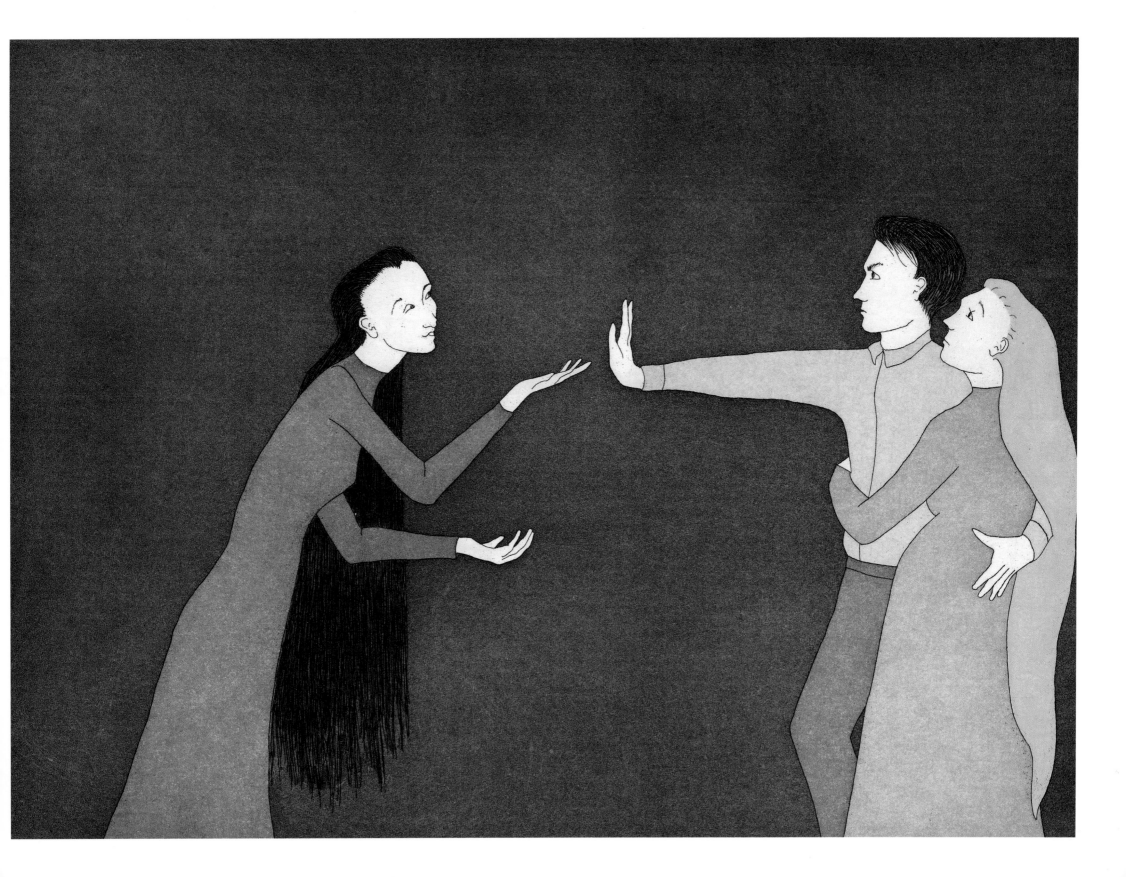

Out, get out of this house!

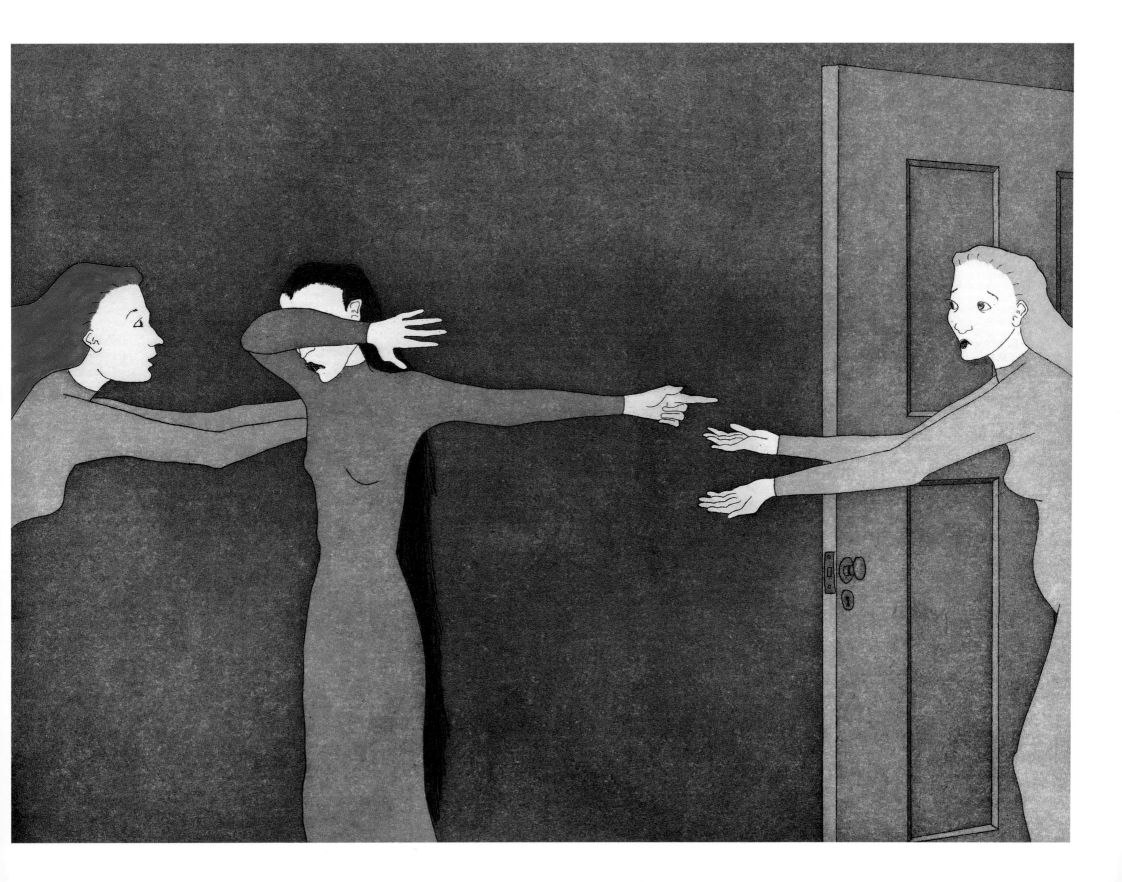

They flee to the city,
but are pursued.

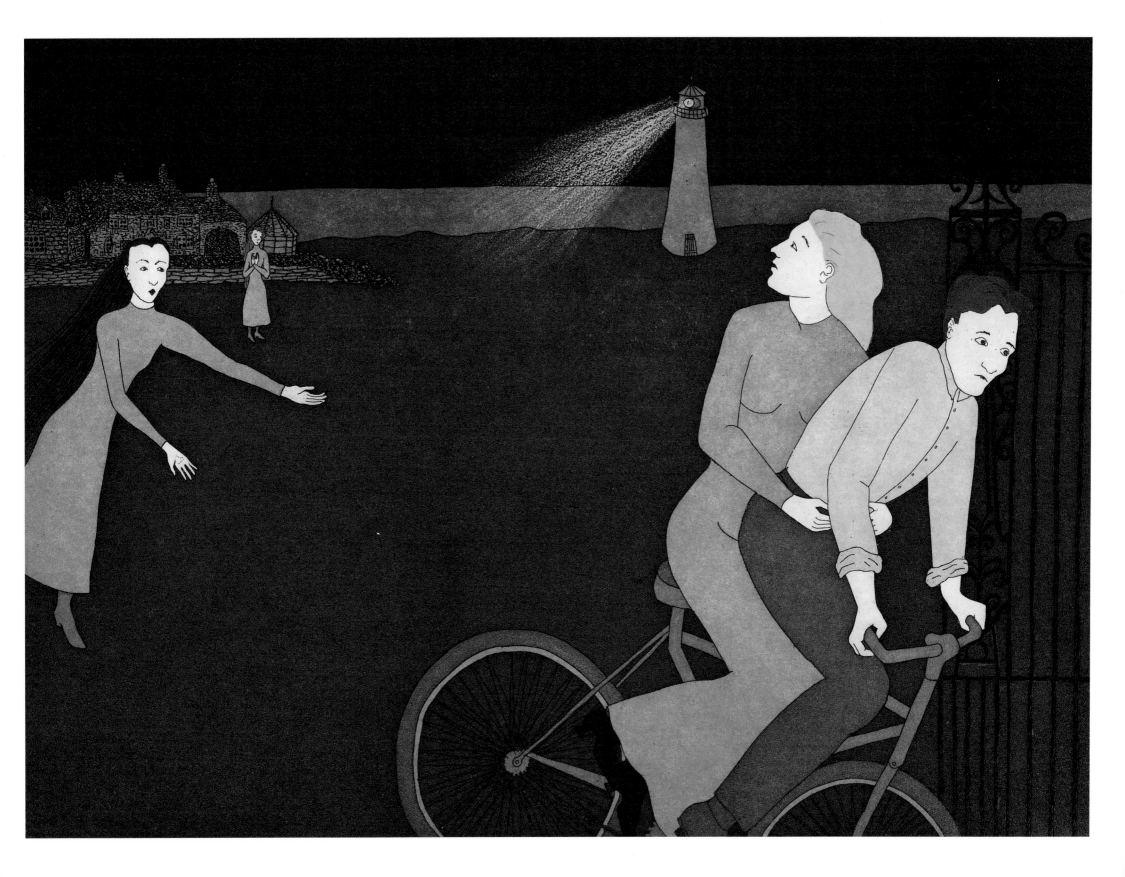

Ophile's revenge:

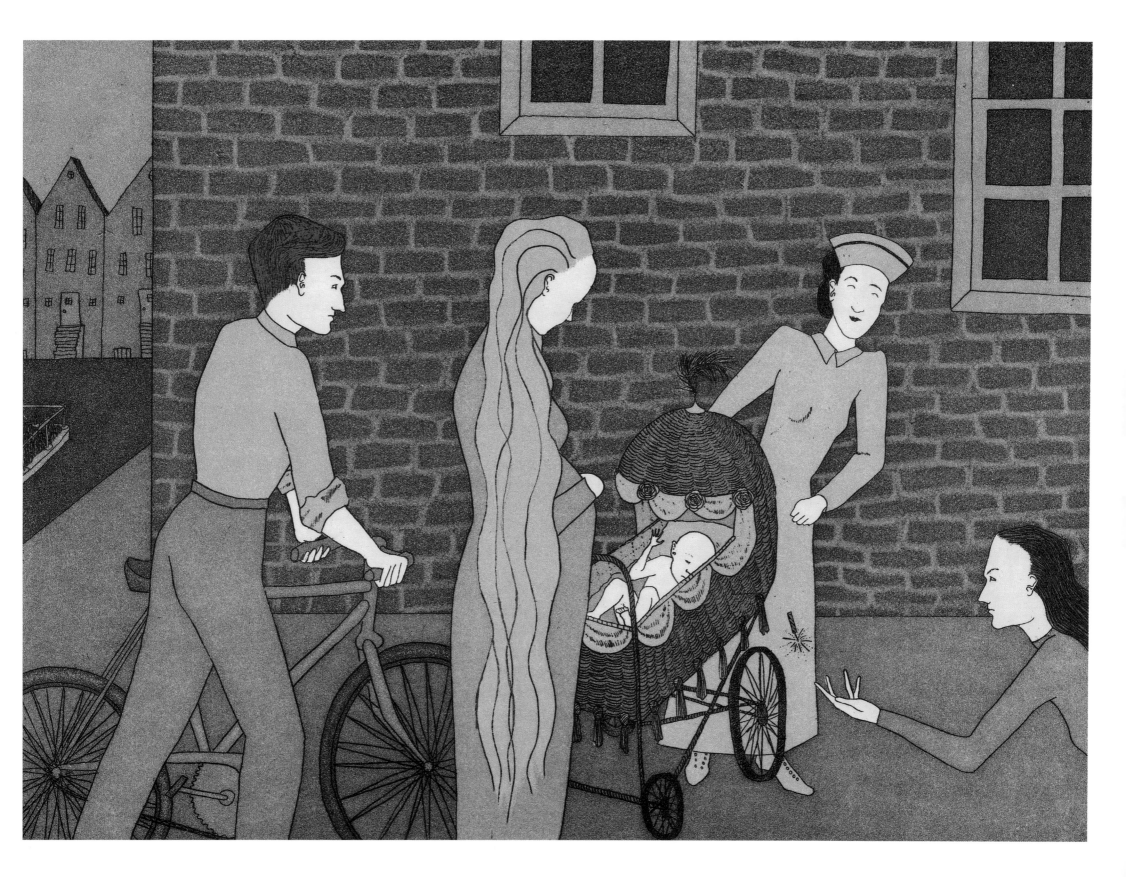

*A firecracker in a
baby carriage!*

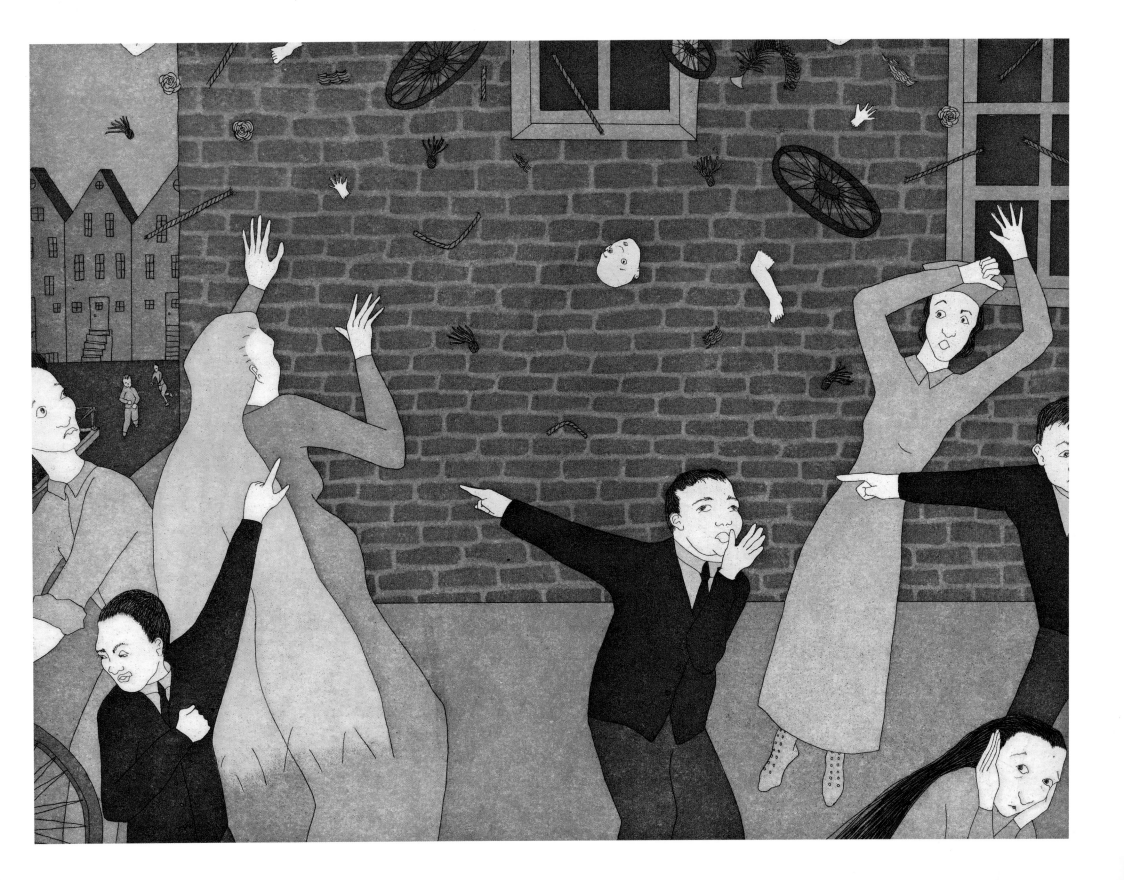

Mistaken identity.

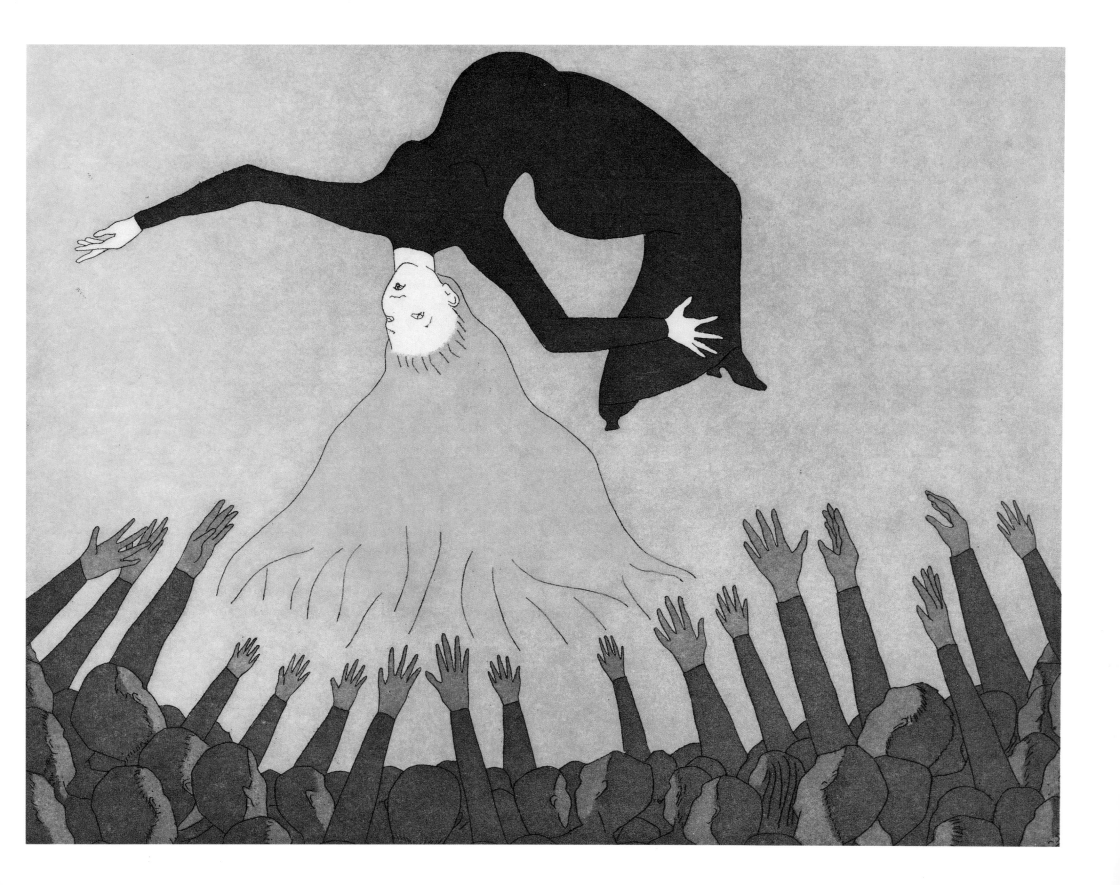

*O*phile, horrified.

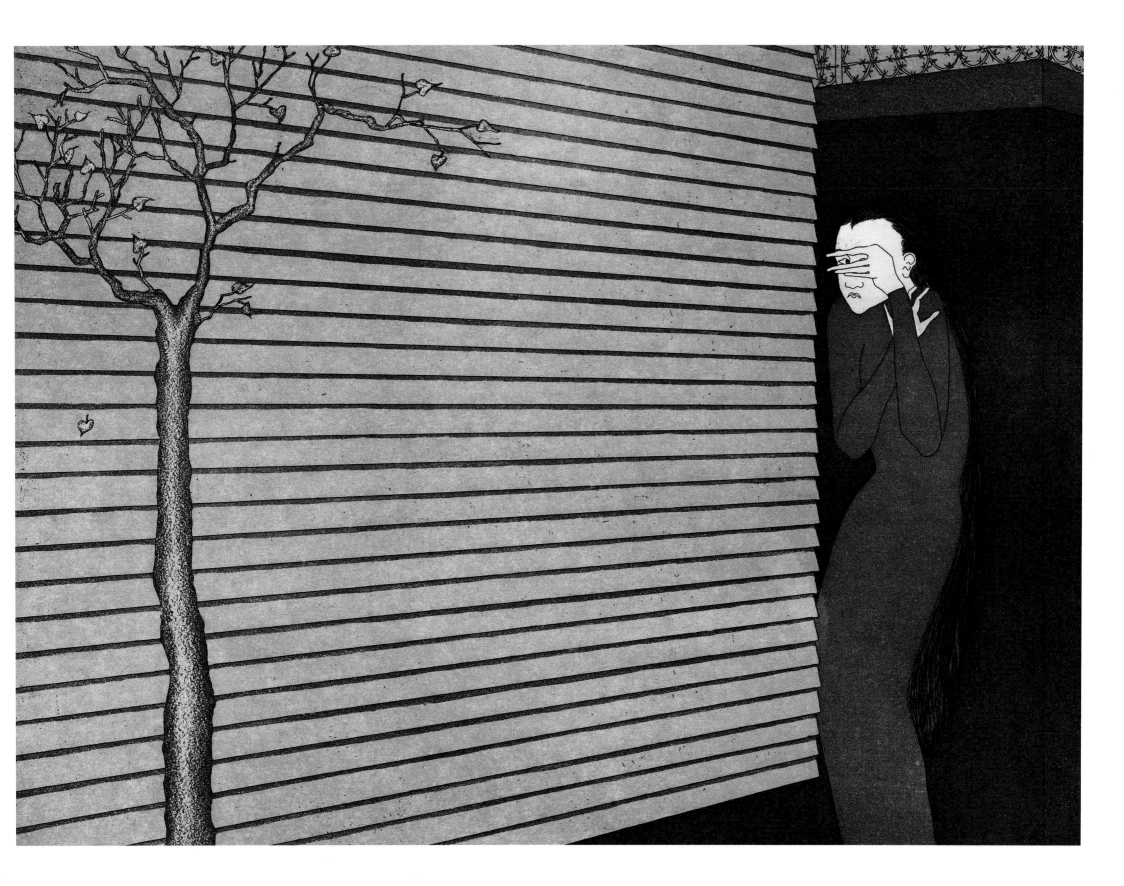

*C*lothilde, horrified.

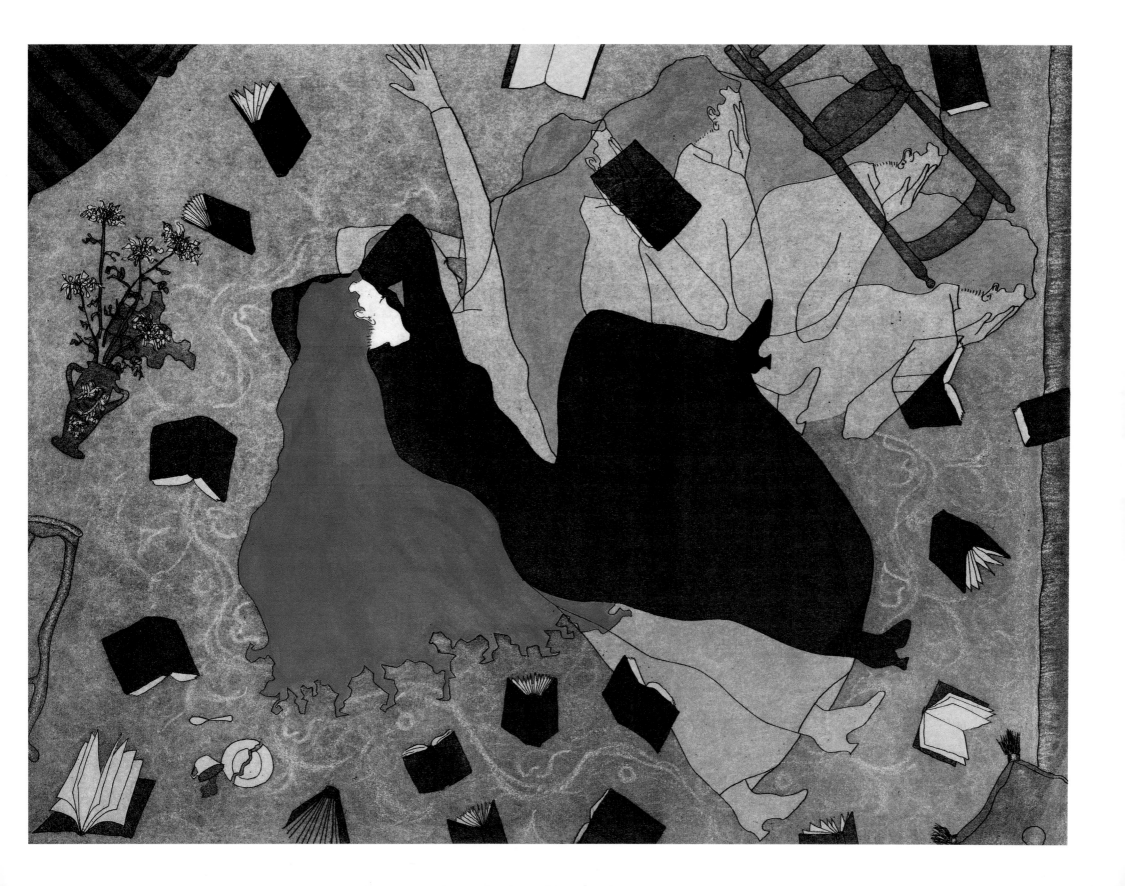

Rescued, but too late.

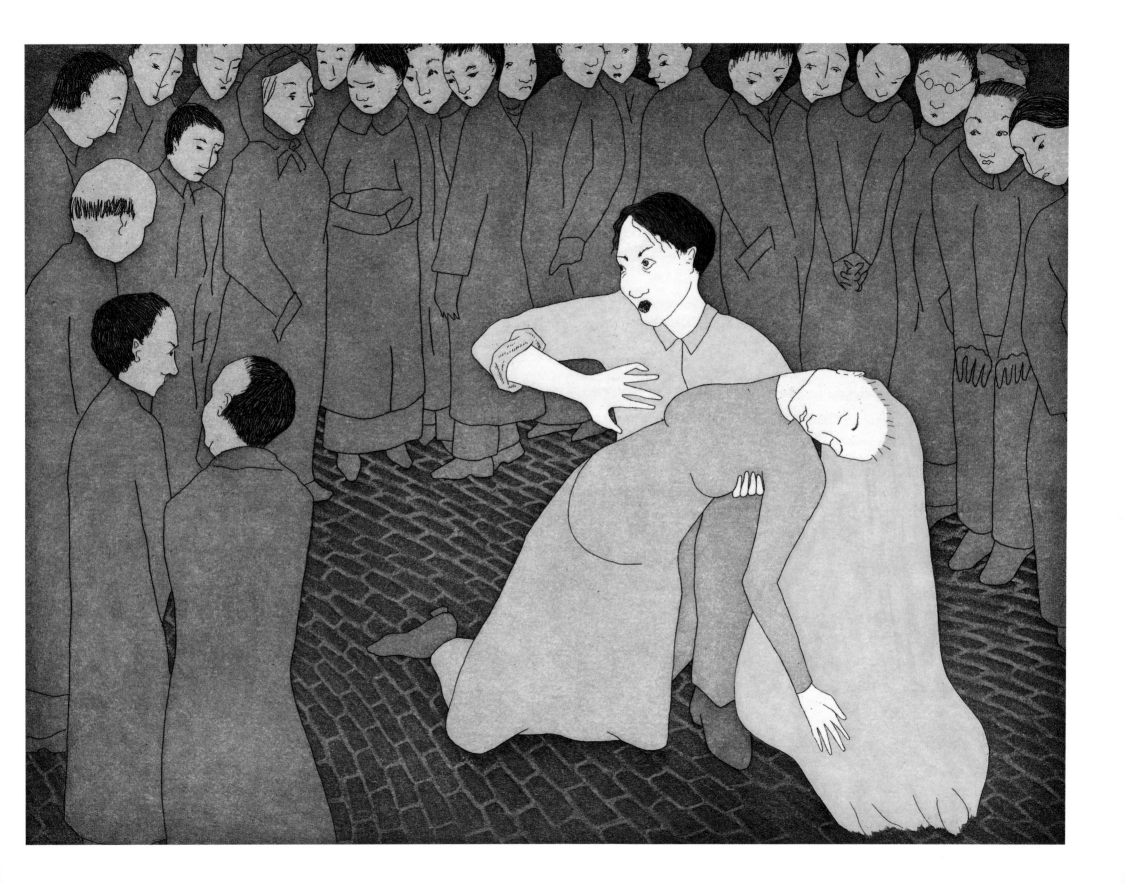

*P*anicked!

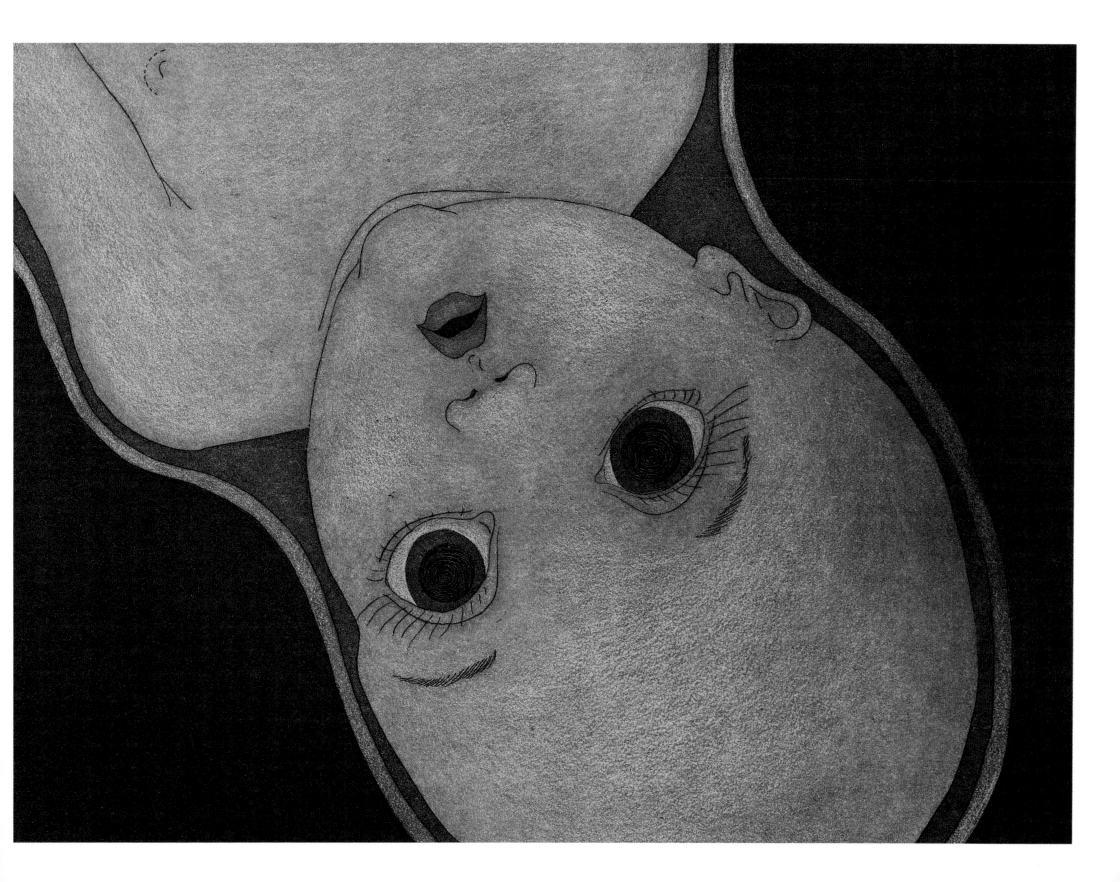

The birth of The Saint.

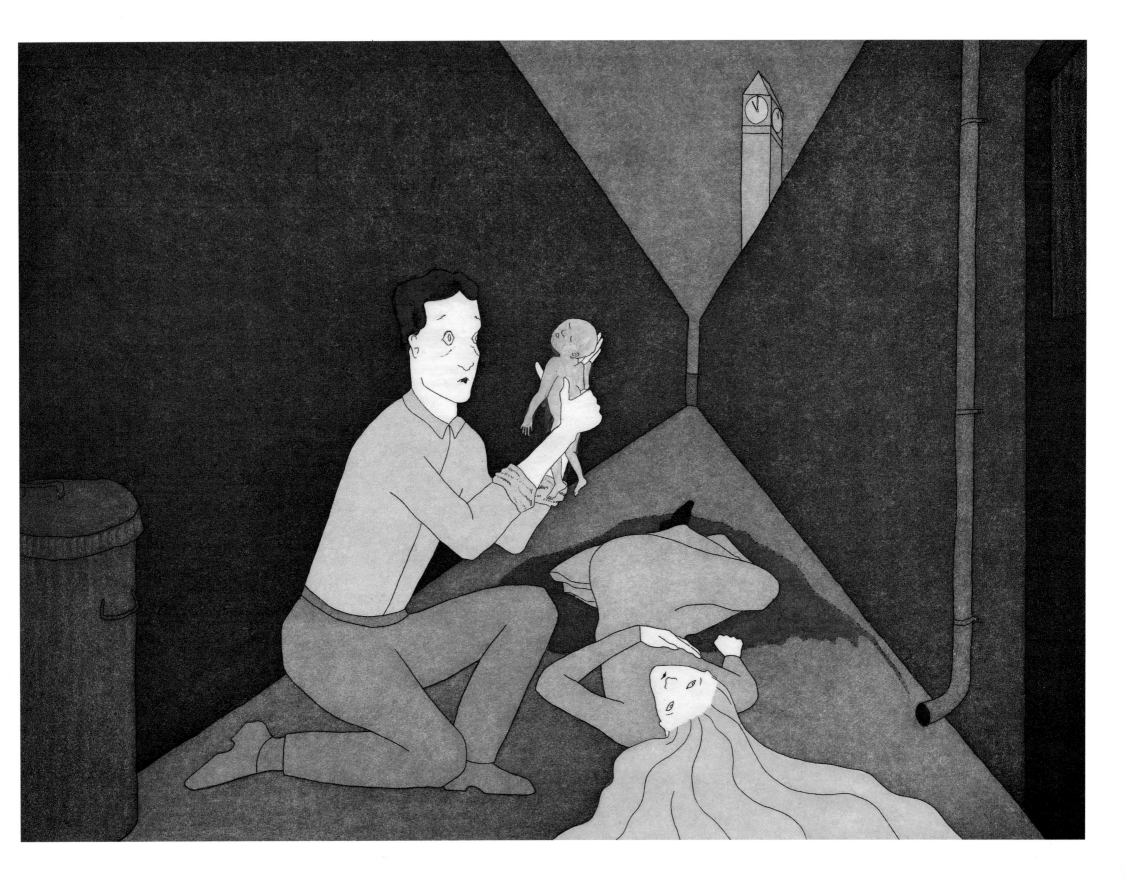

The death of Bettine.

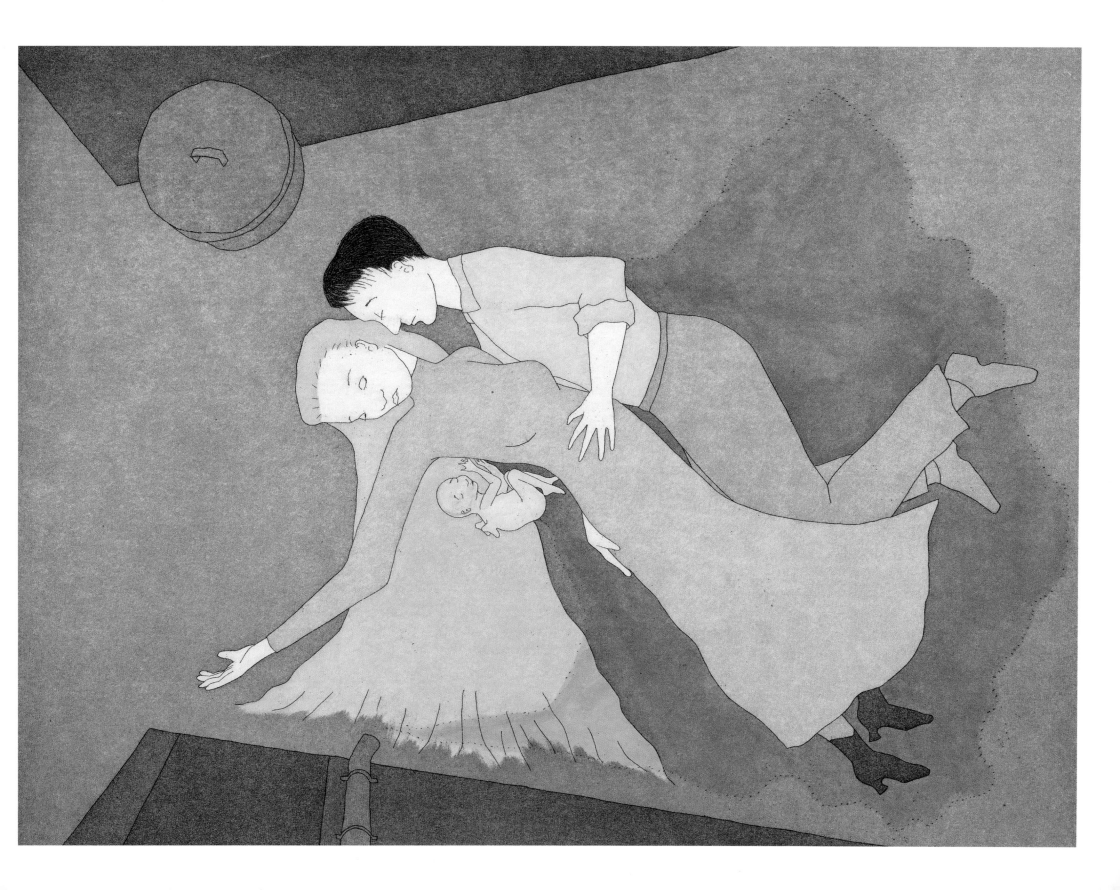

*M*adness and grief;
a plea for forgiveness.

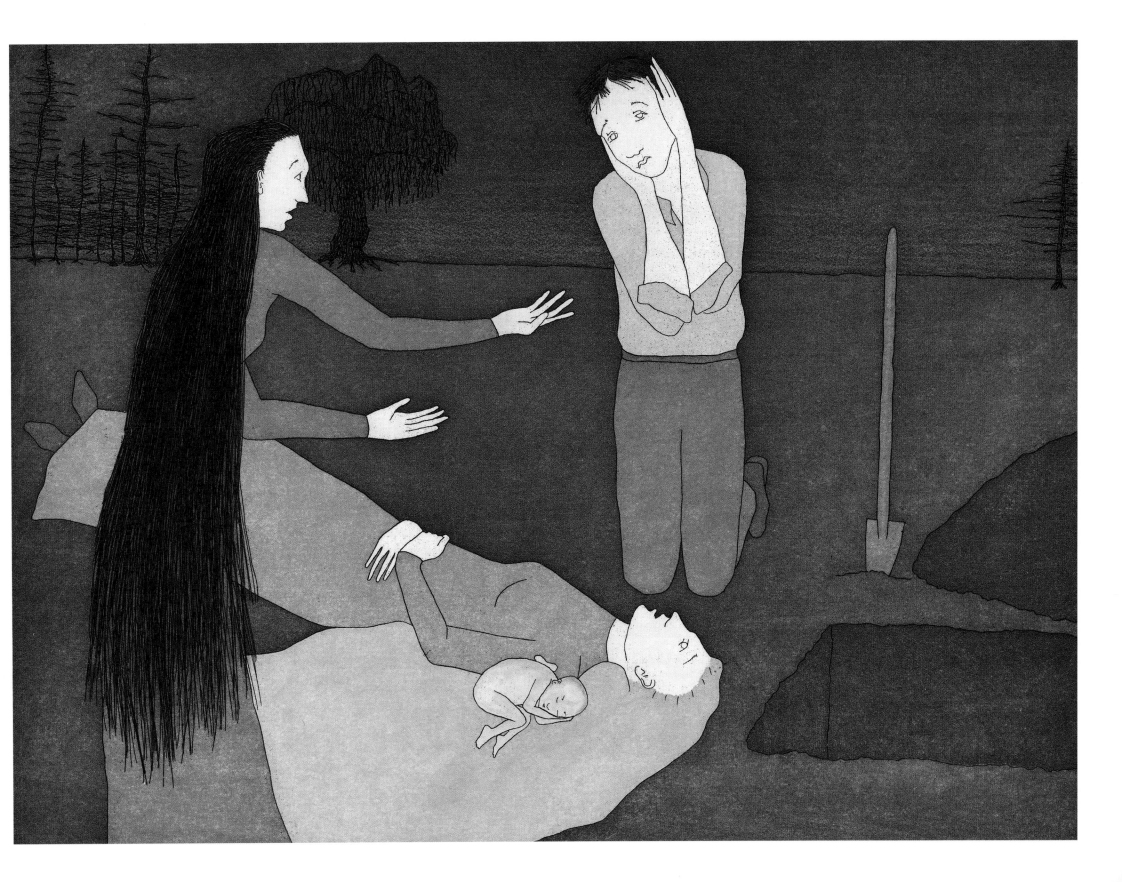

*P*aris runs away to sea.

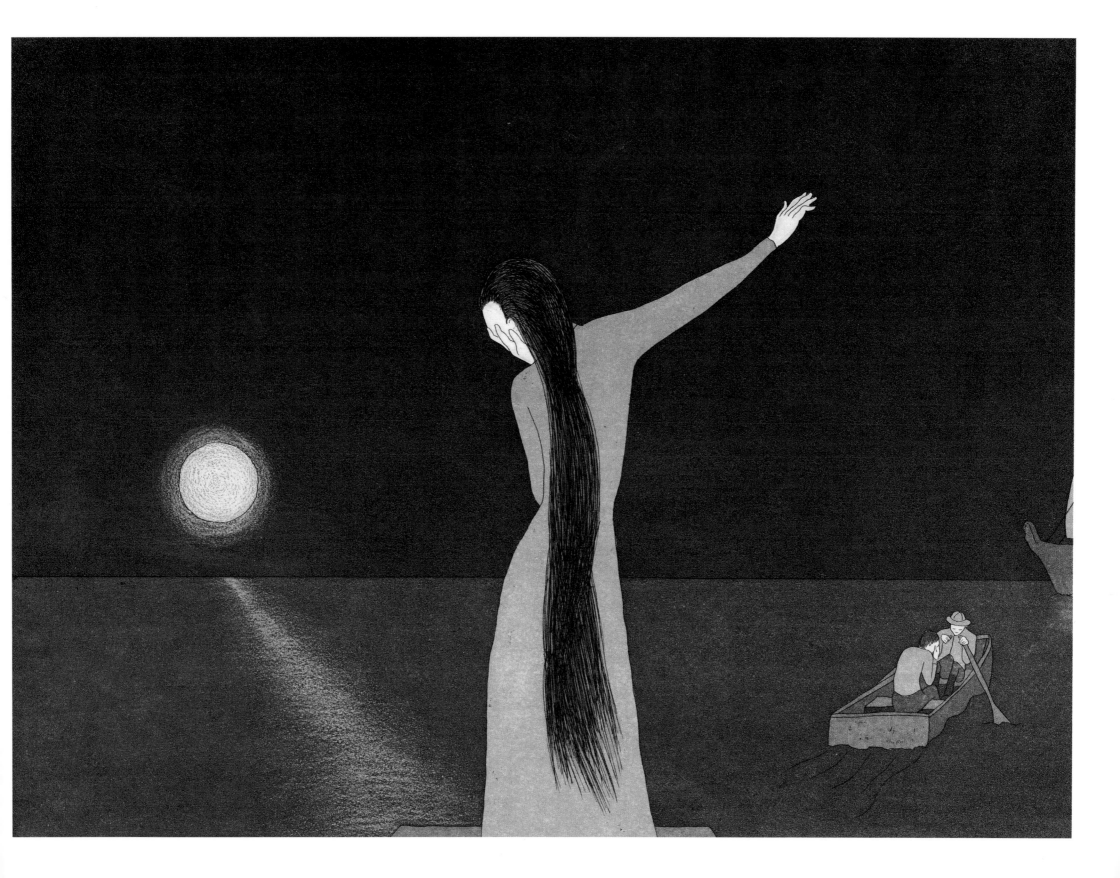

His small voice is gone, gone forever.

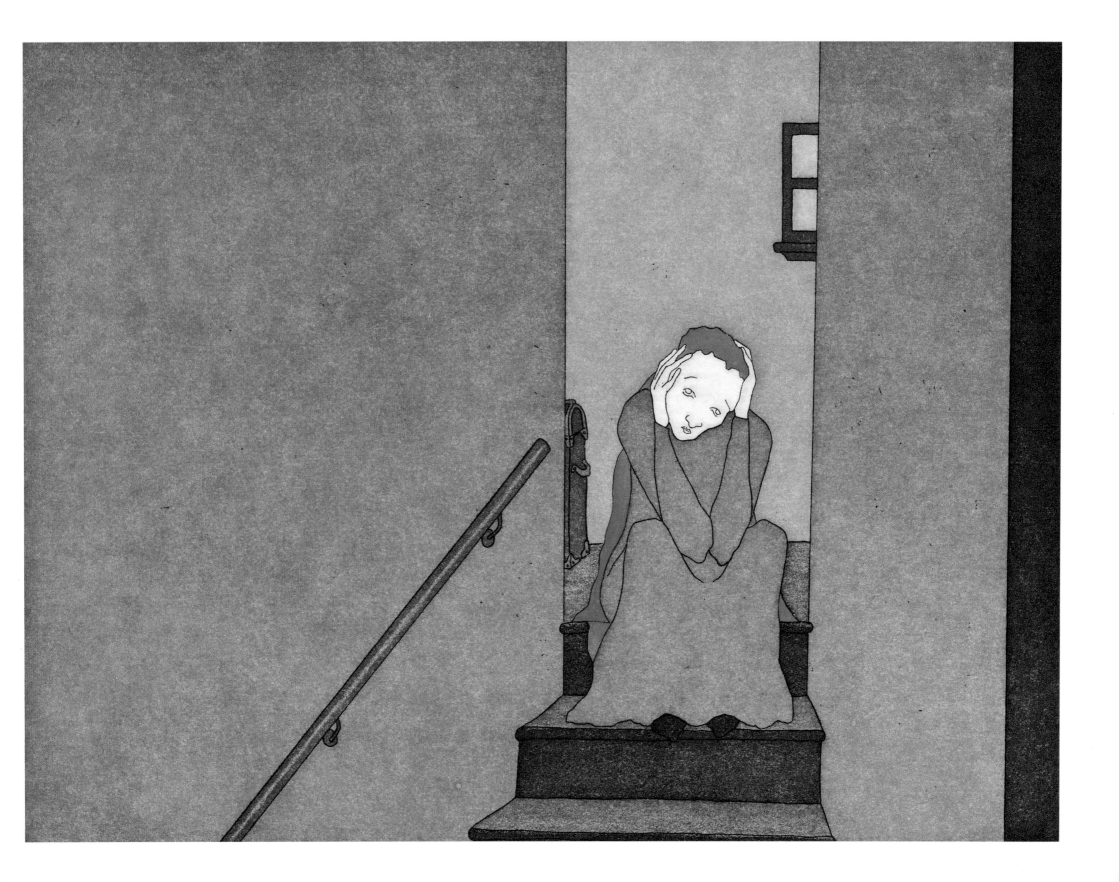

Ophile, waiting for
Paris's ship to come in.

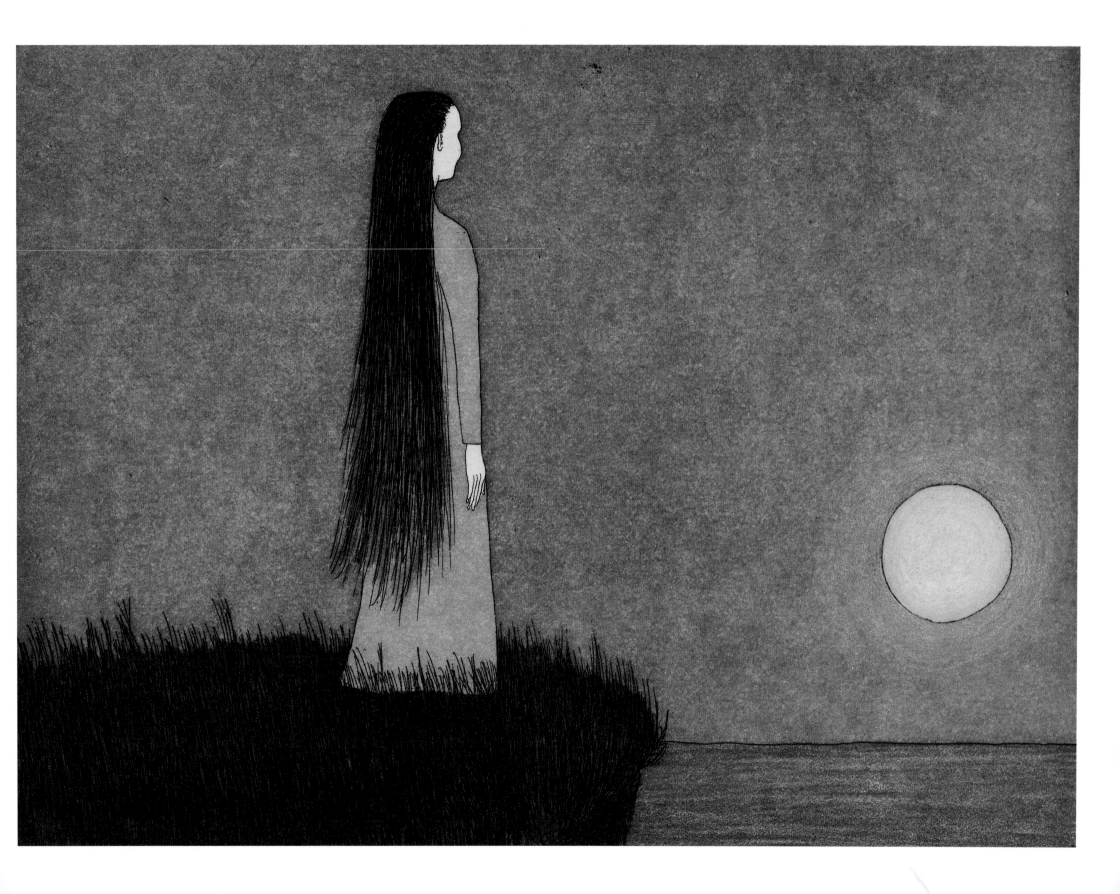

*H*aunted.

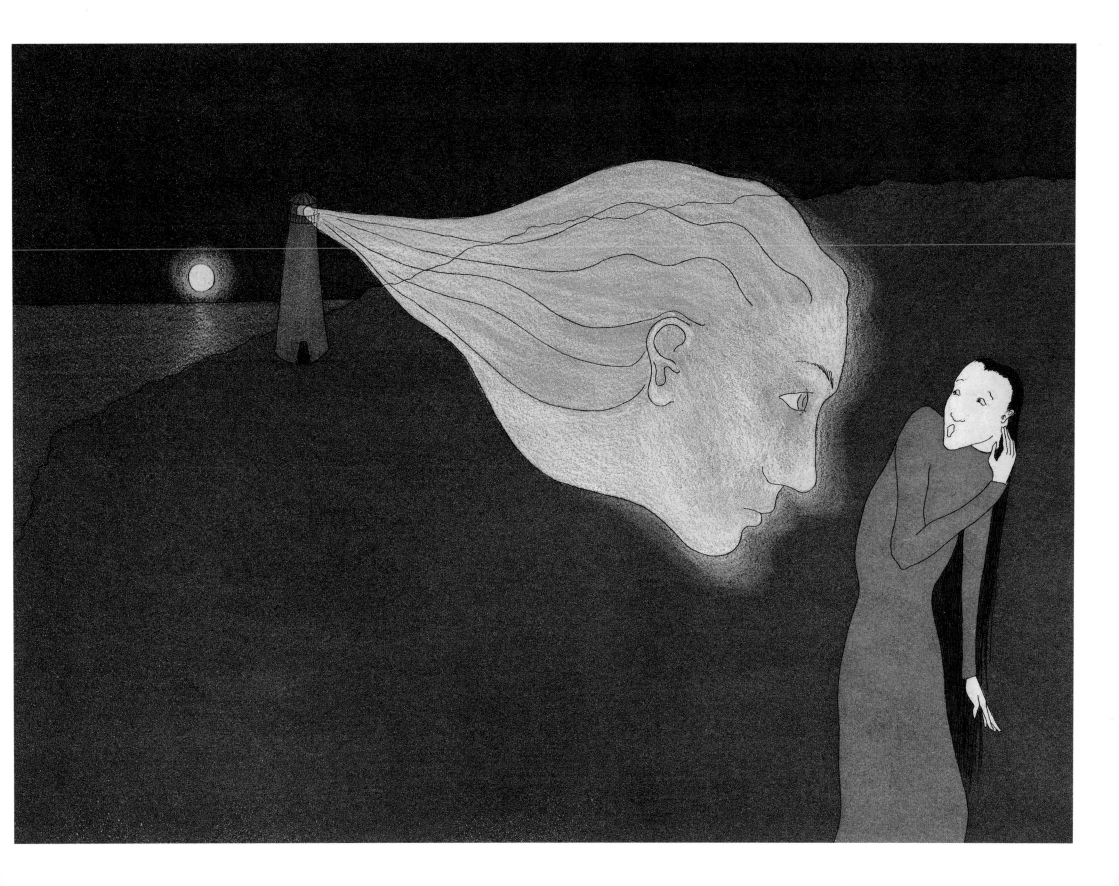

*H*aunted.

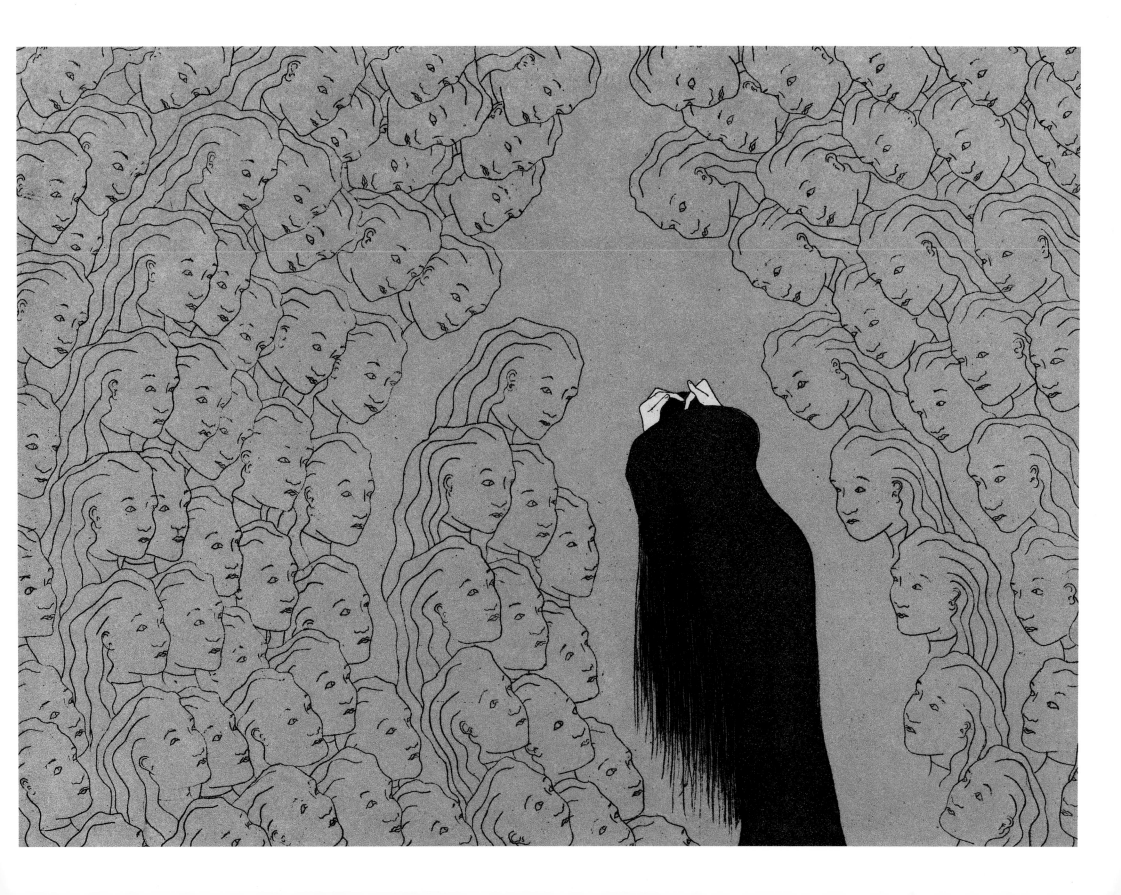

Ophile is reproached by
the ghosts of her parents.

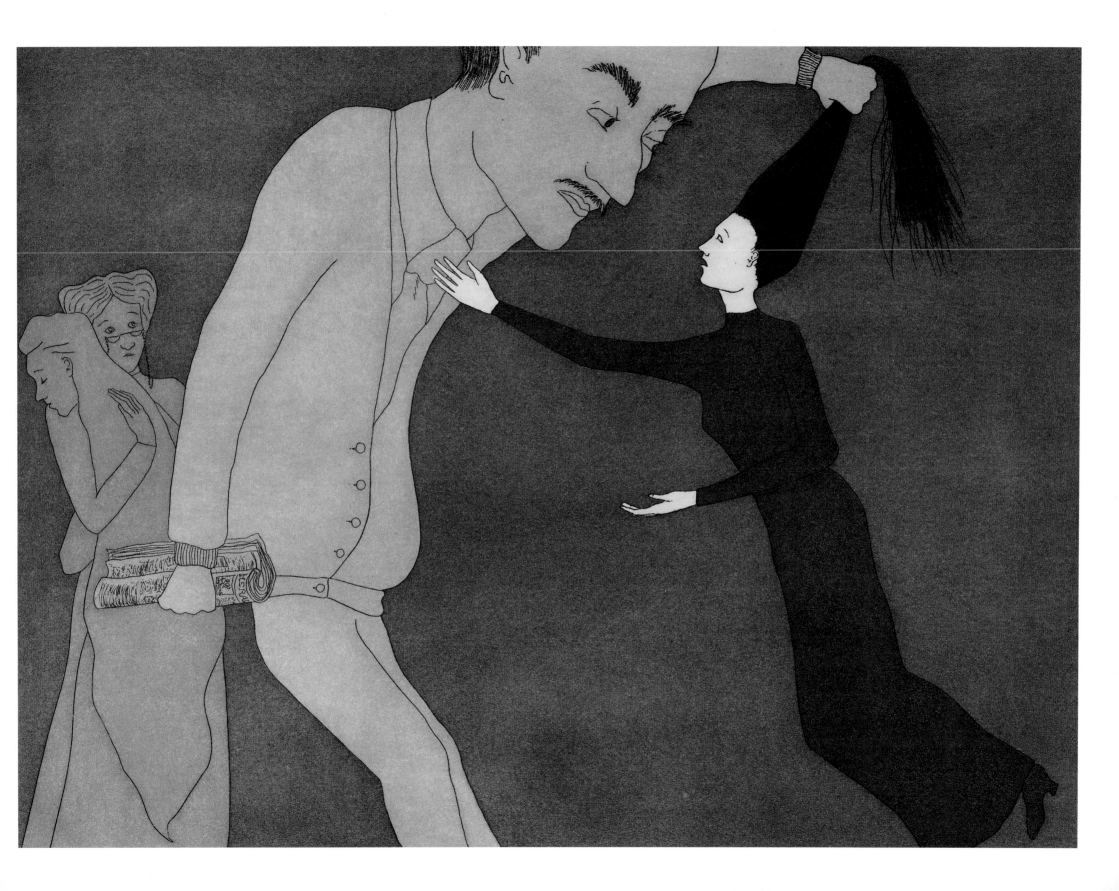

Overwhelmed by remorse,
Ophile throws herself
from the lighthouse.

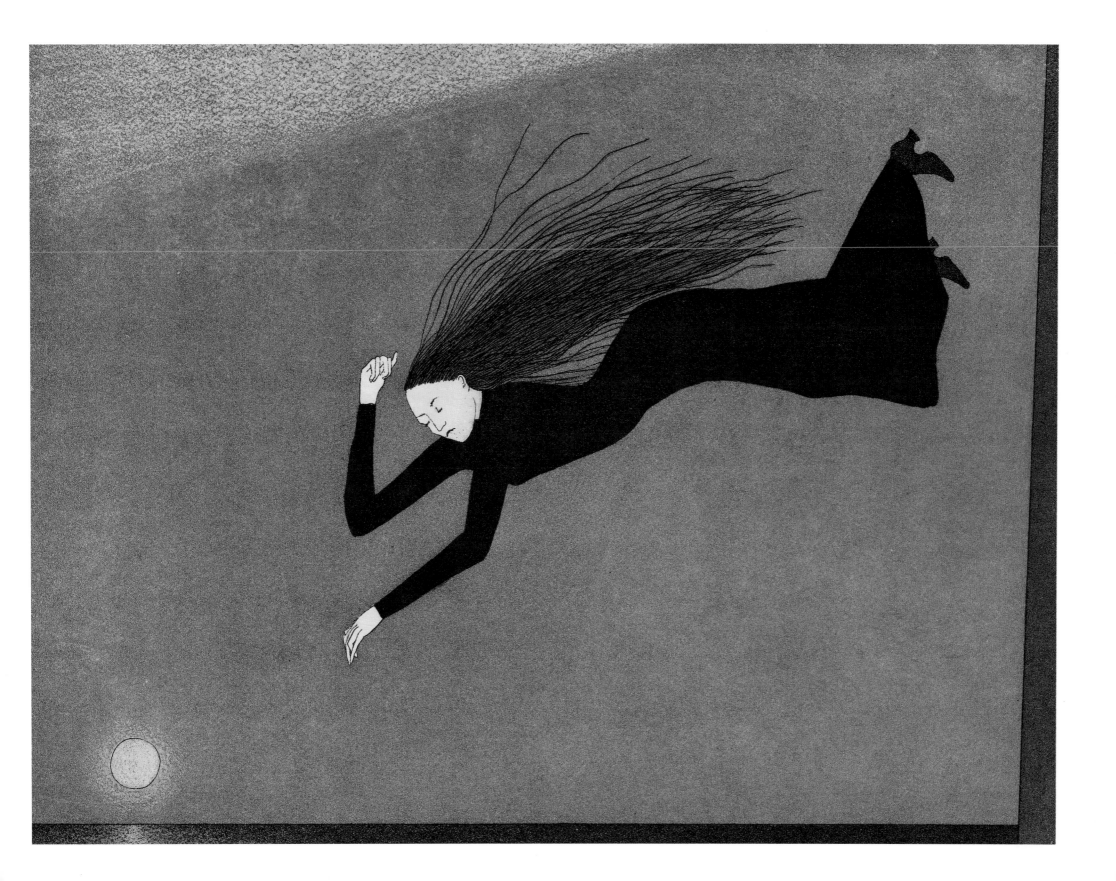

*D*rowning, drowning
in sadness, and the sea.

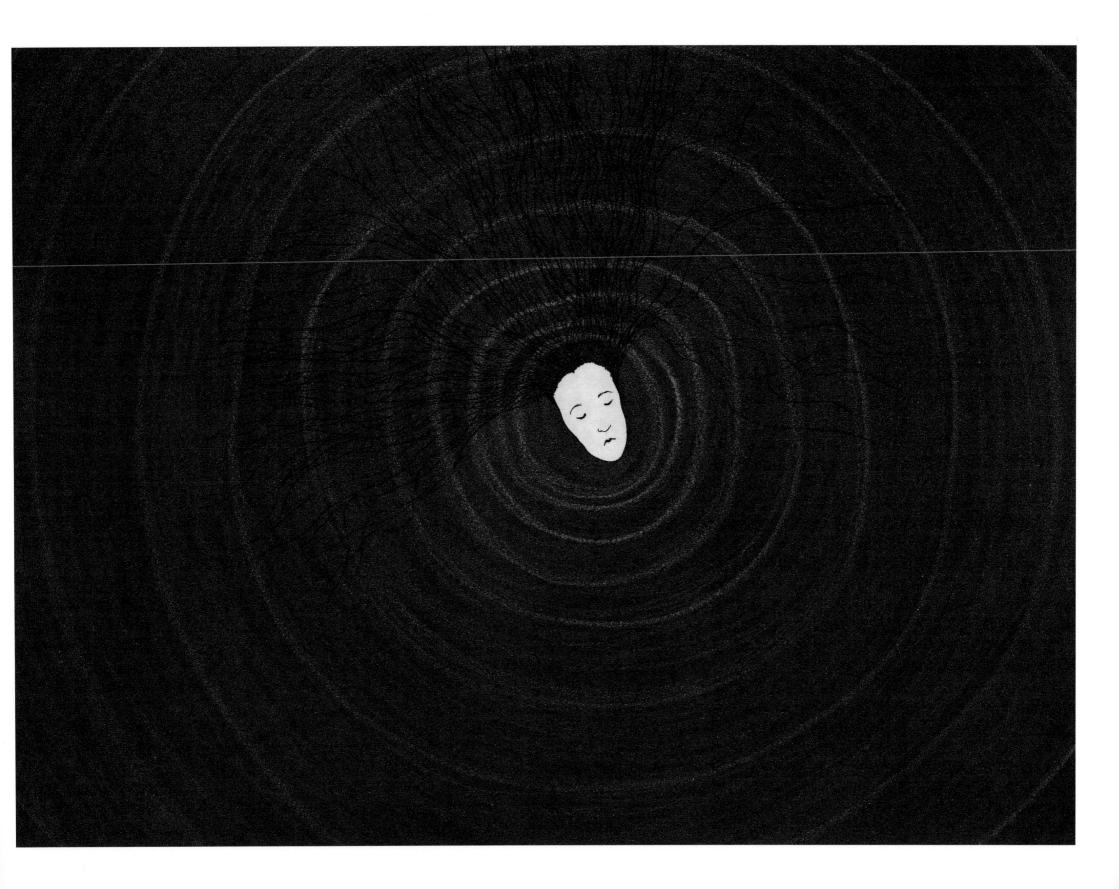

CLOTHILDE

*M*any years pass.
Clothilde lives sadly,
alone in the house.

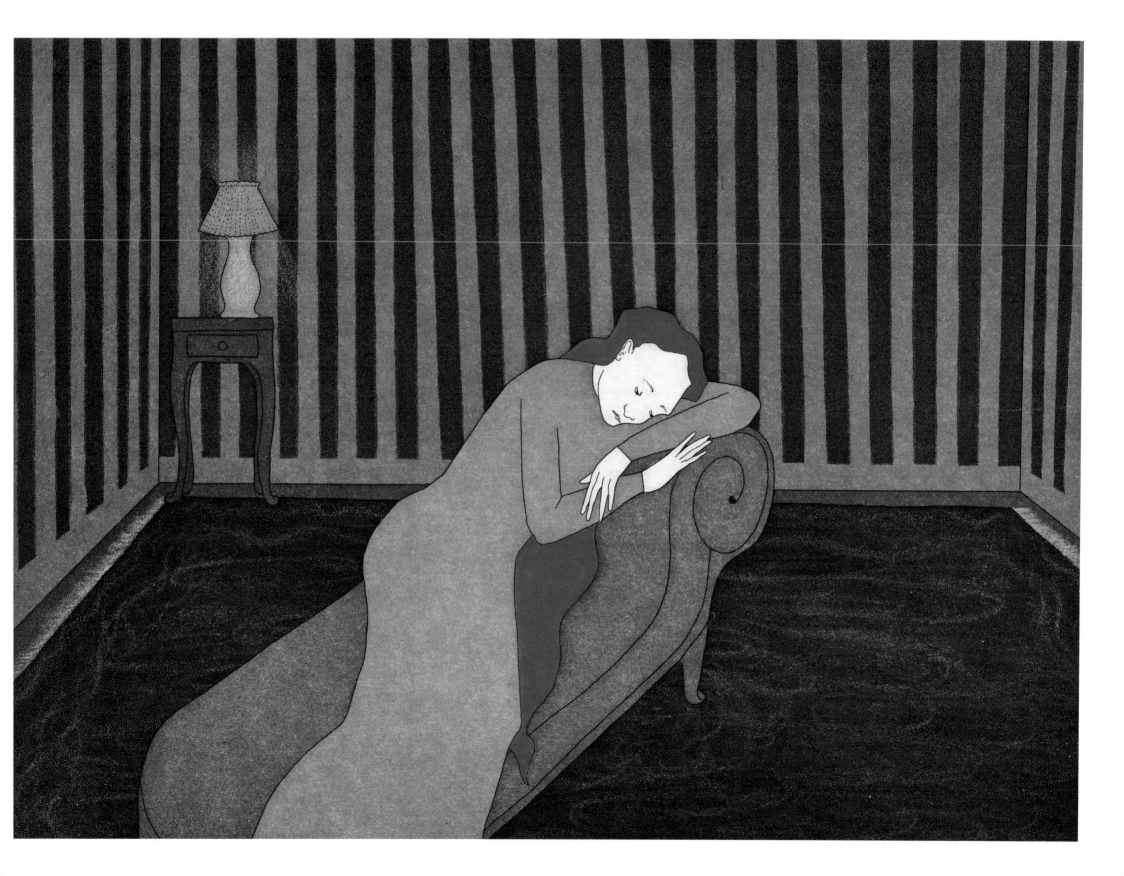

Suddenly one day,
she hears a voice:
Here I am, here I am!
Not dead at all! Come
to the City, Clothilde!

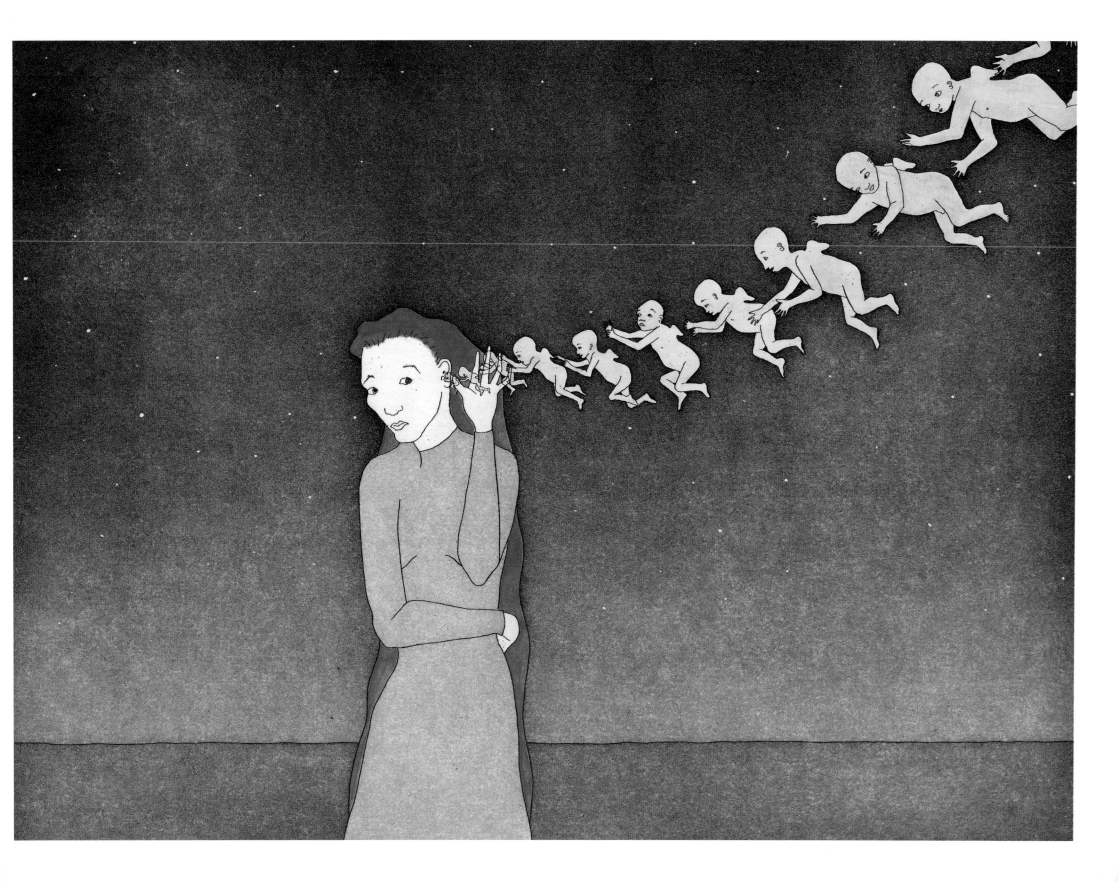

The Circus is coming to town.

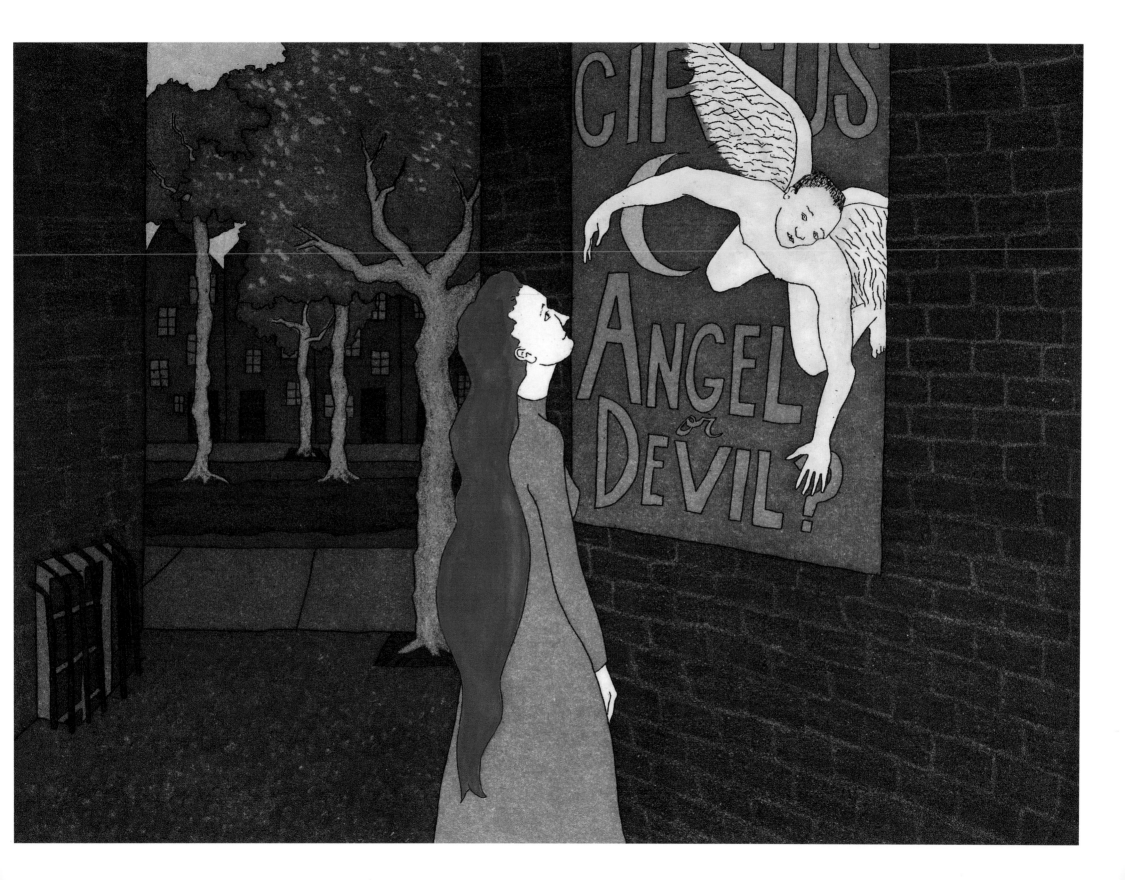

A Circus Parade.

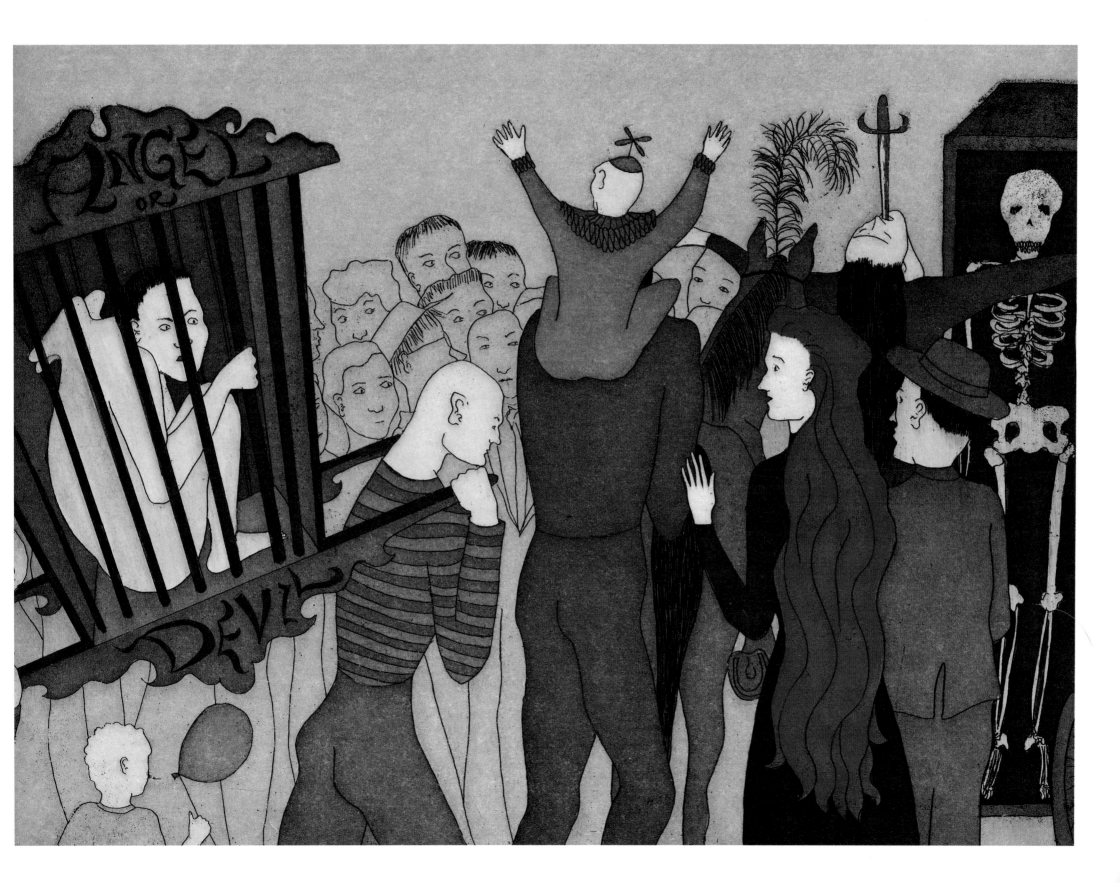

The Amazing Flying Boy!

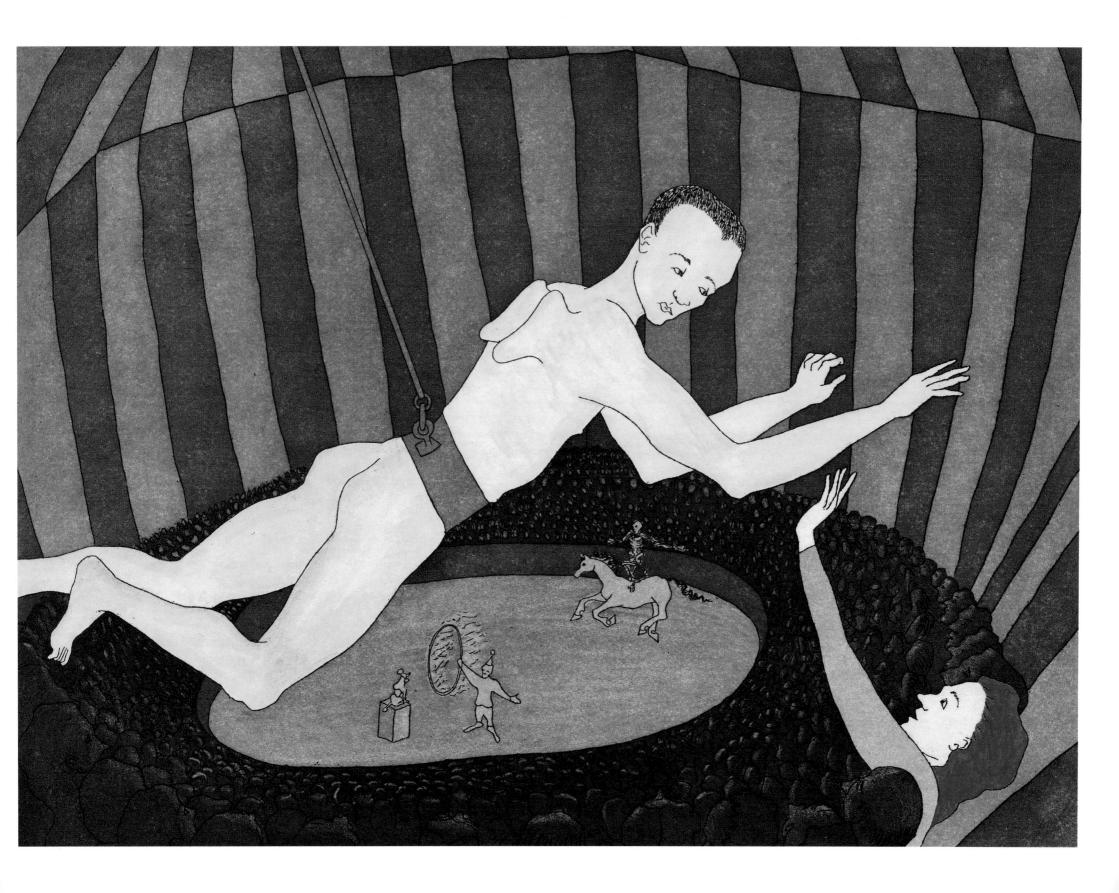

Liberation.

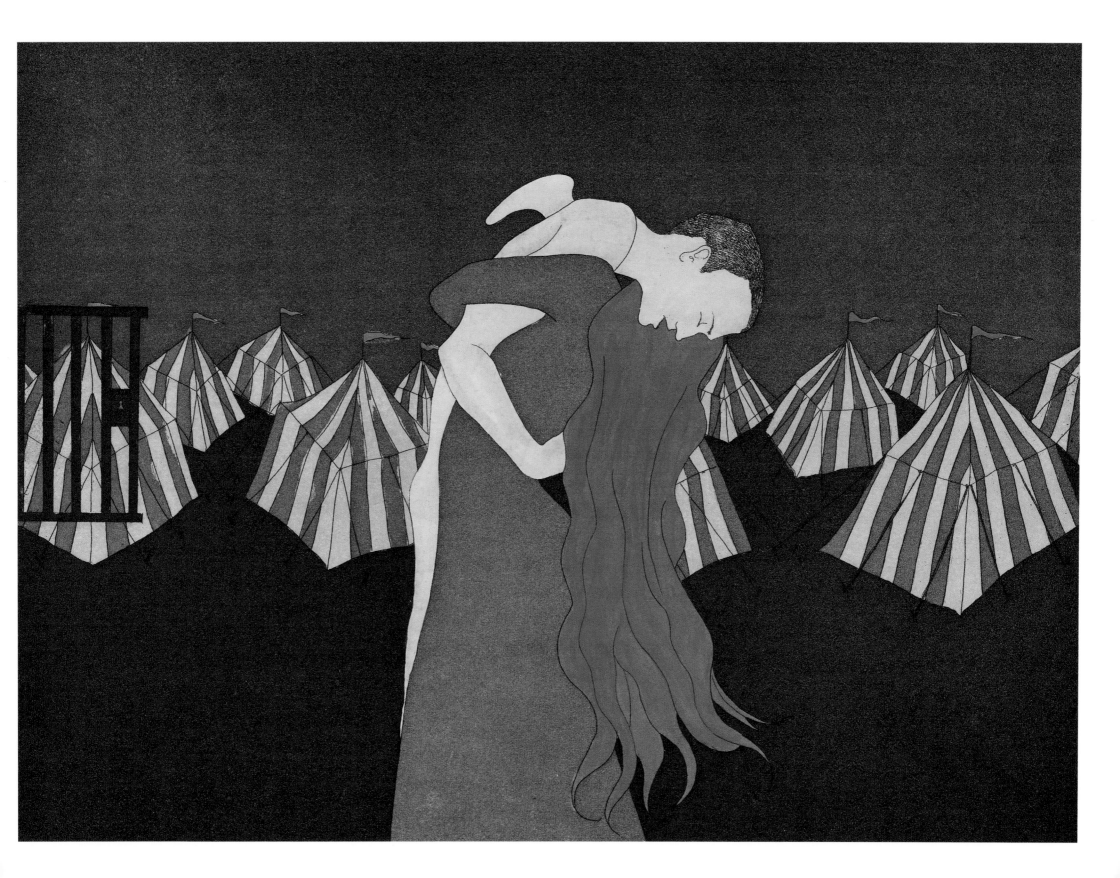

*H*e reads her mind
like a book.

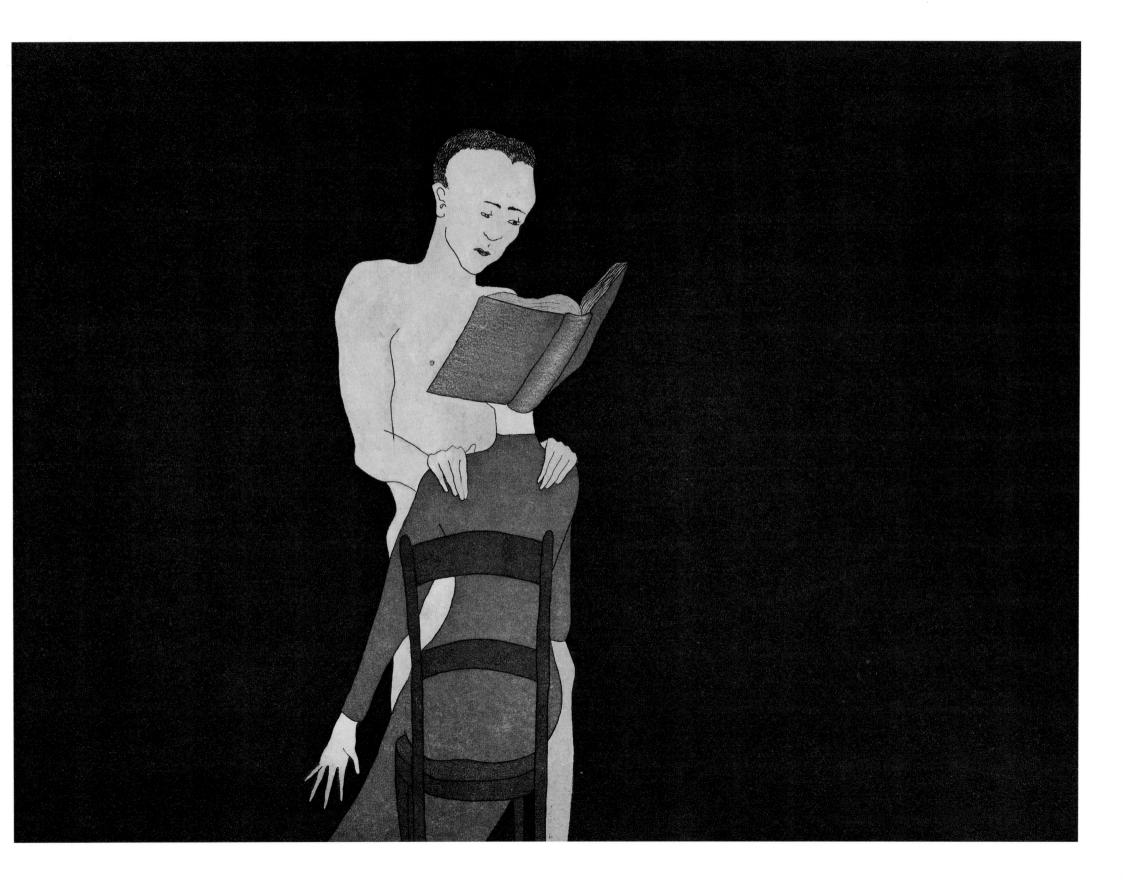

The Saint tells Clothilde his story:

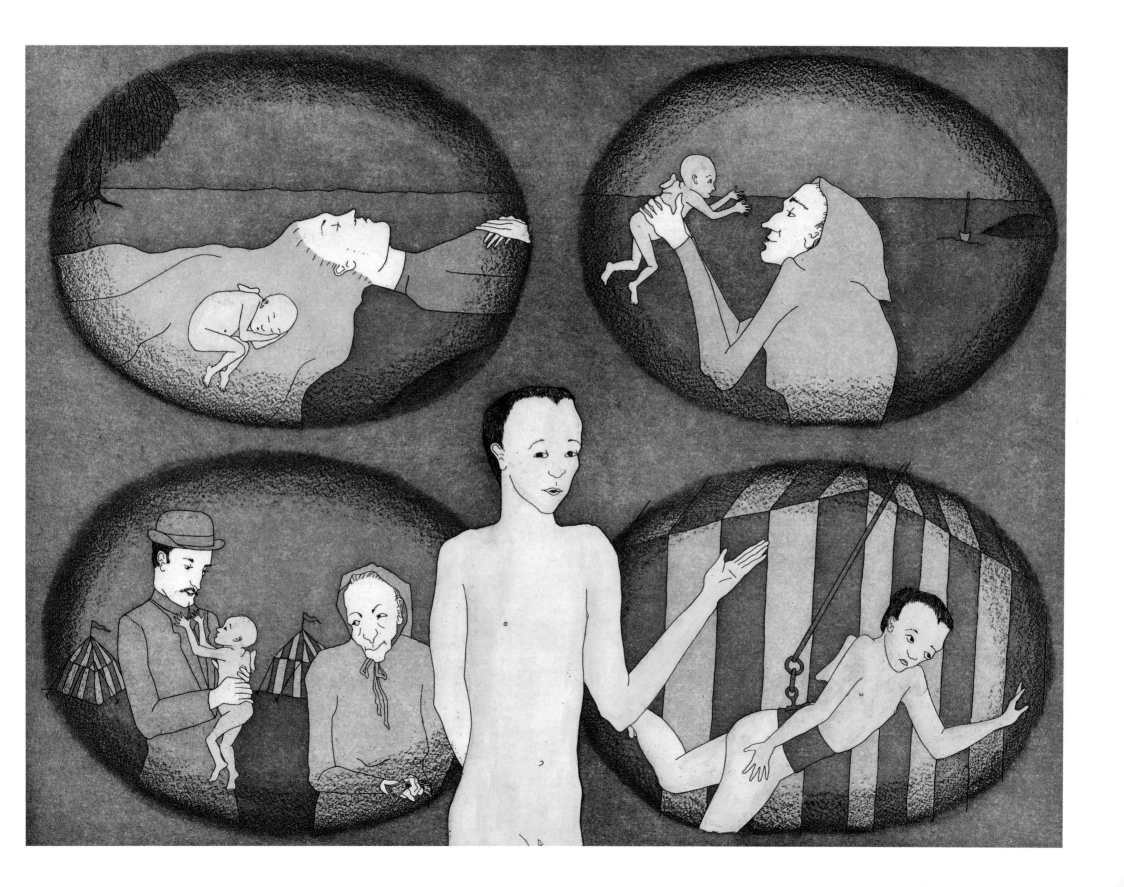

Don't be sad; look!

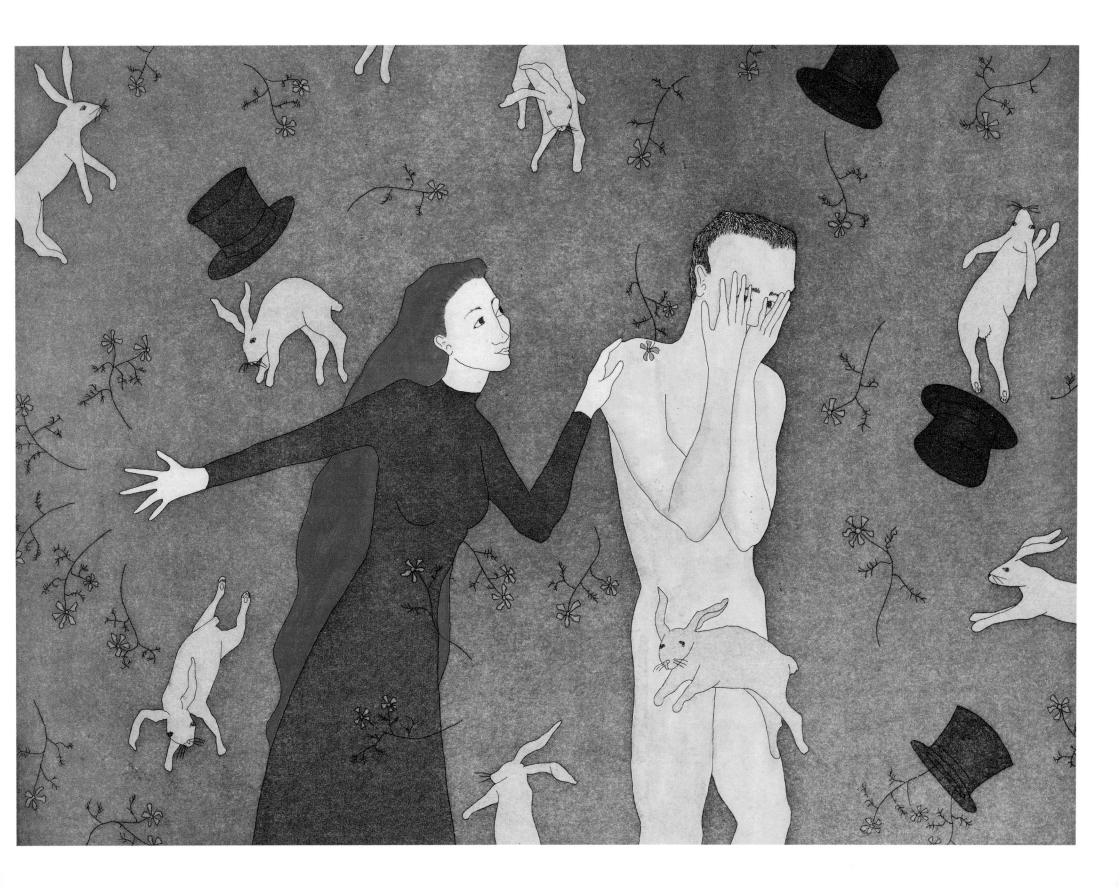

*T*he levitation lesson:

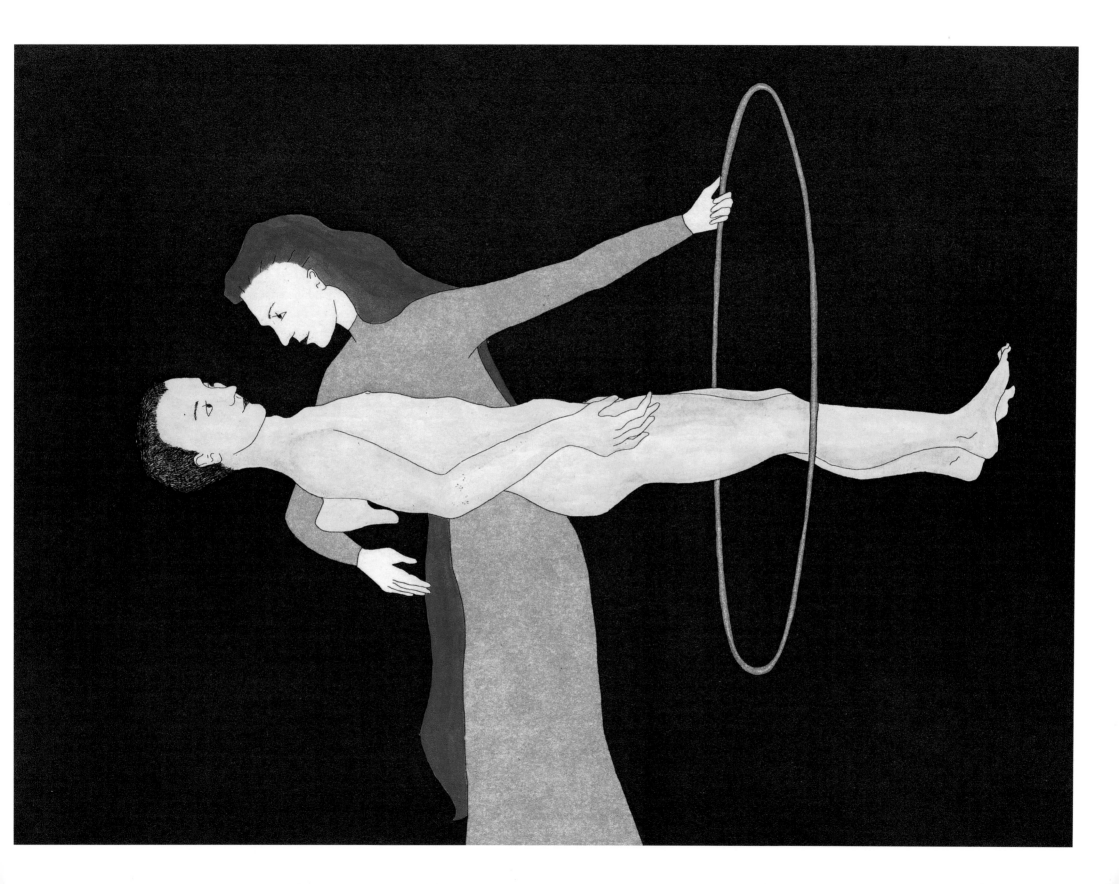

The invisibility lesson:

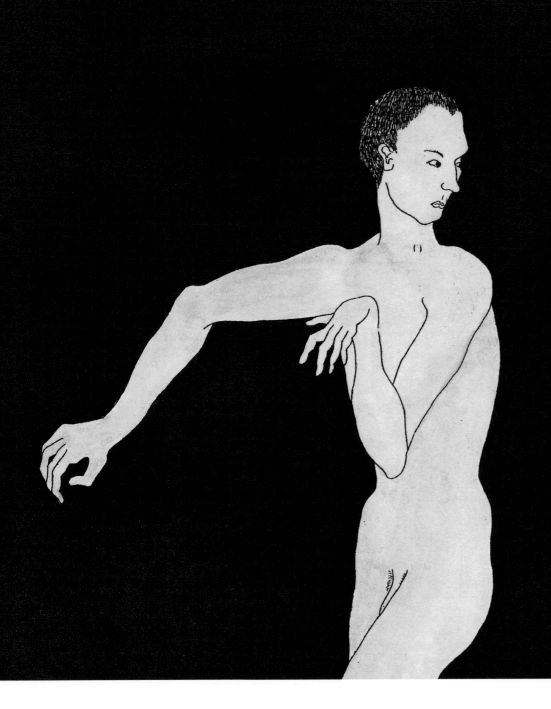

The flying lesson:
Flying at last, like a bird,
above all the houses and trees.

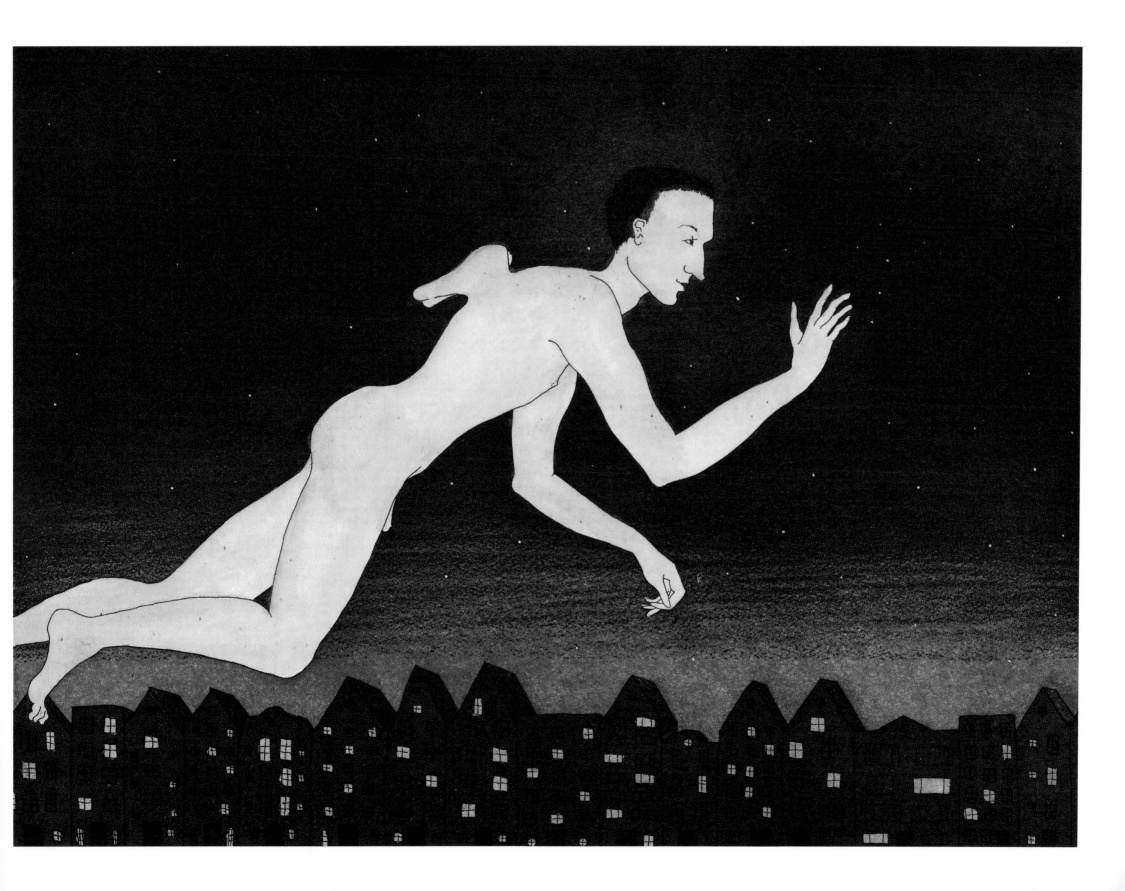

A trip to the Aquarium:

Here is someone you should meet.

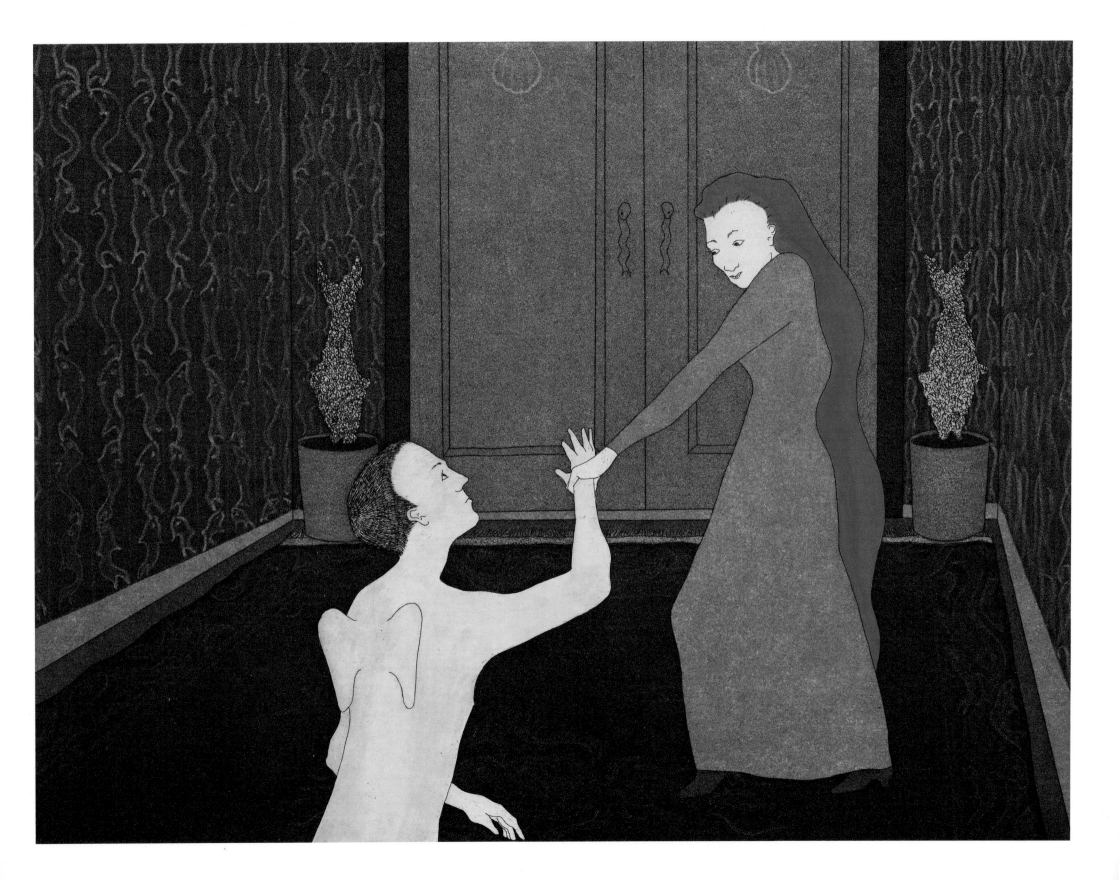

This is your Father.

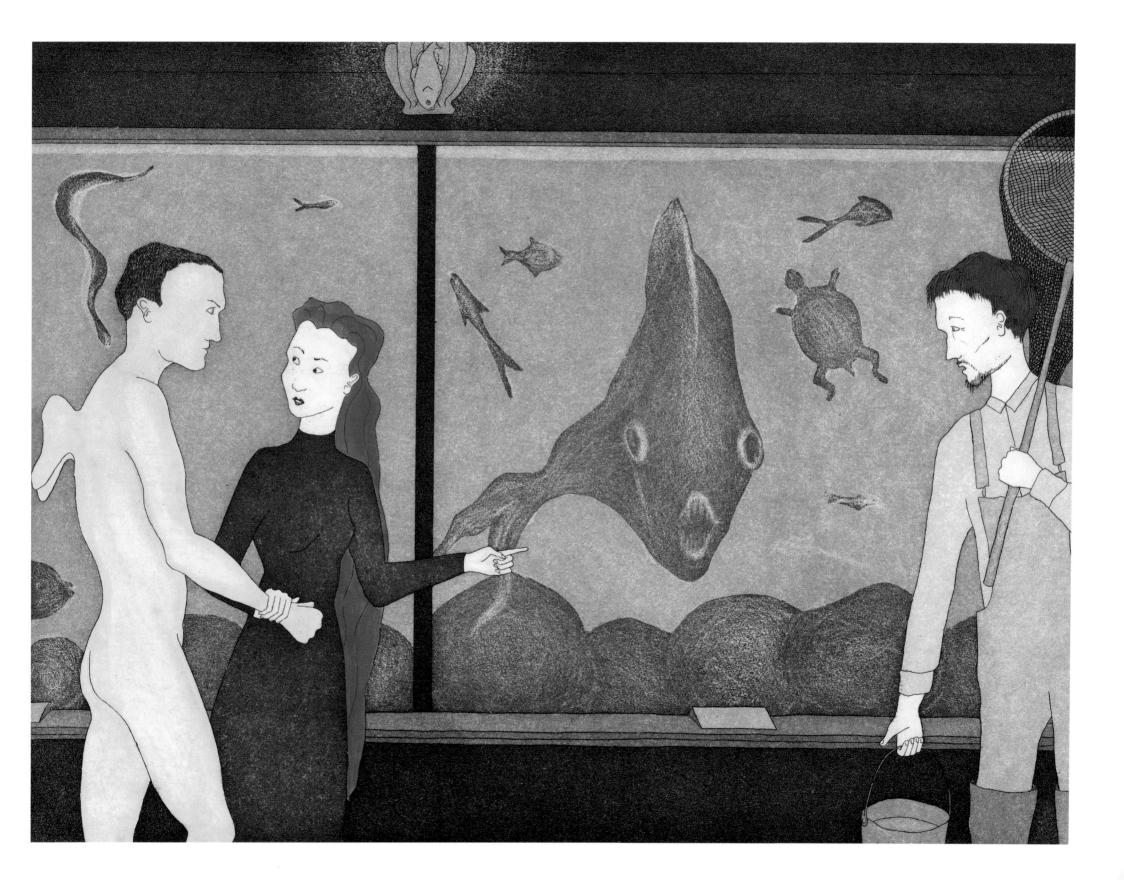

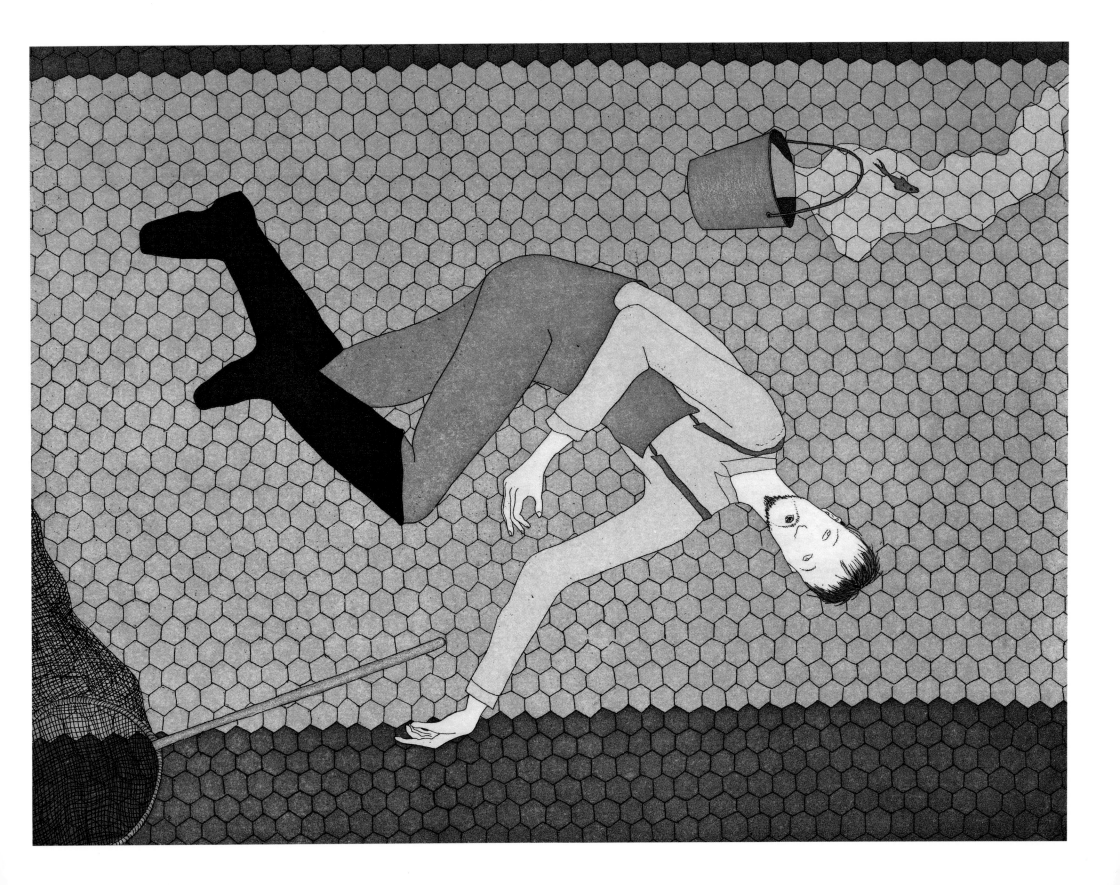

Reunion.

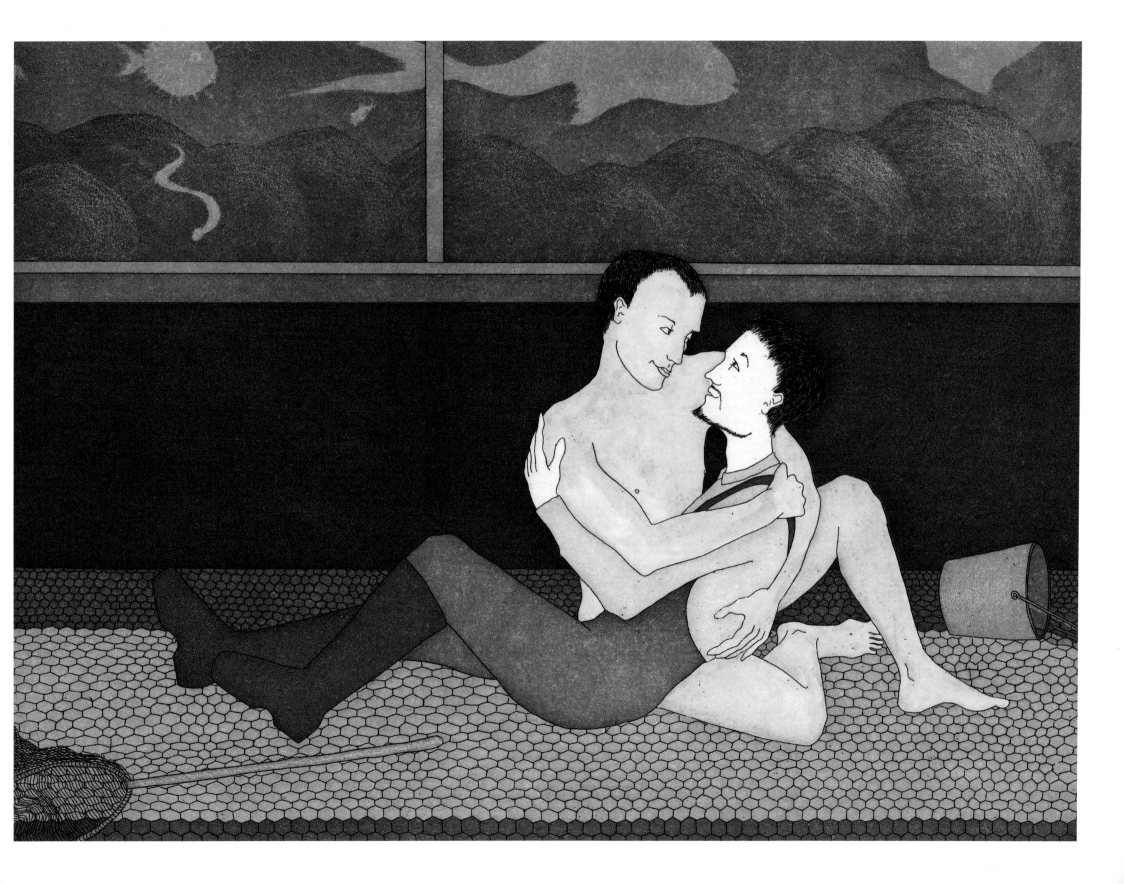

All this time, we
thought you had died . . .

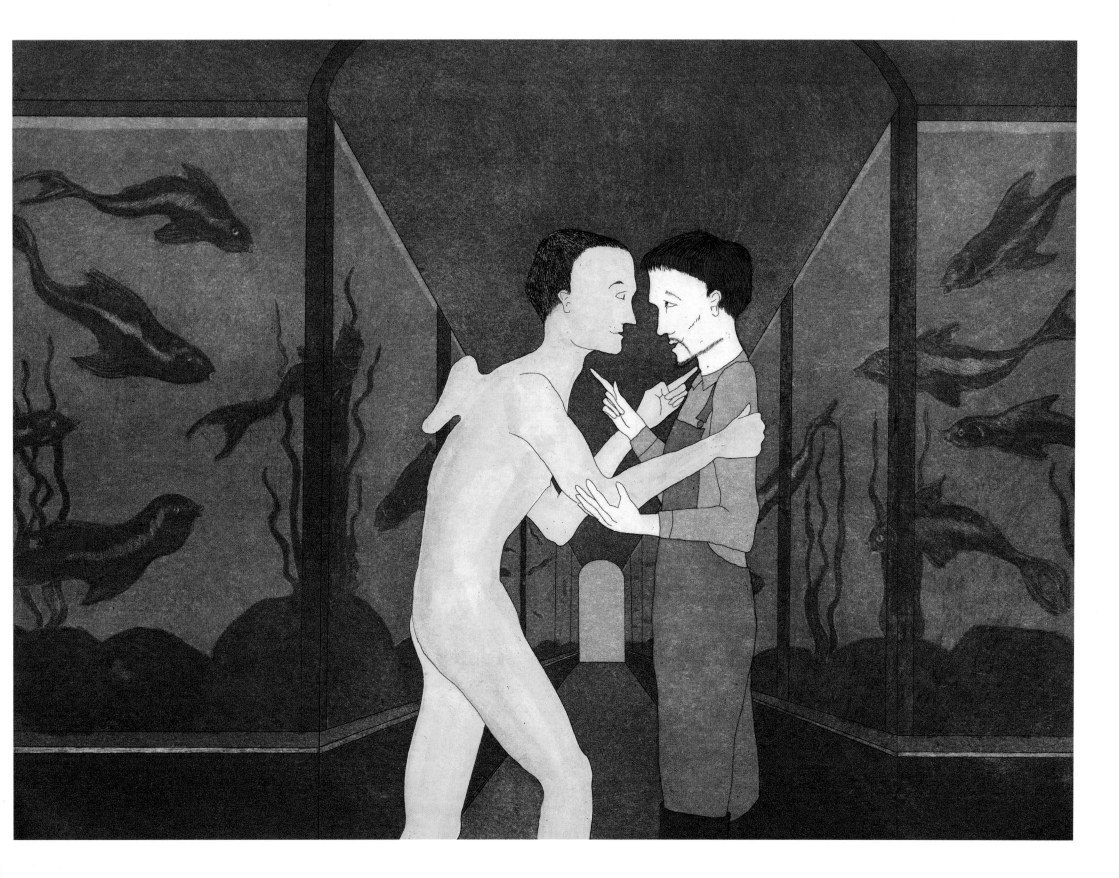

Returning home.

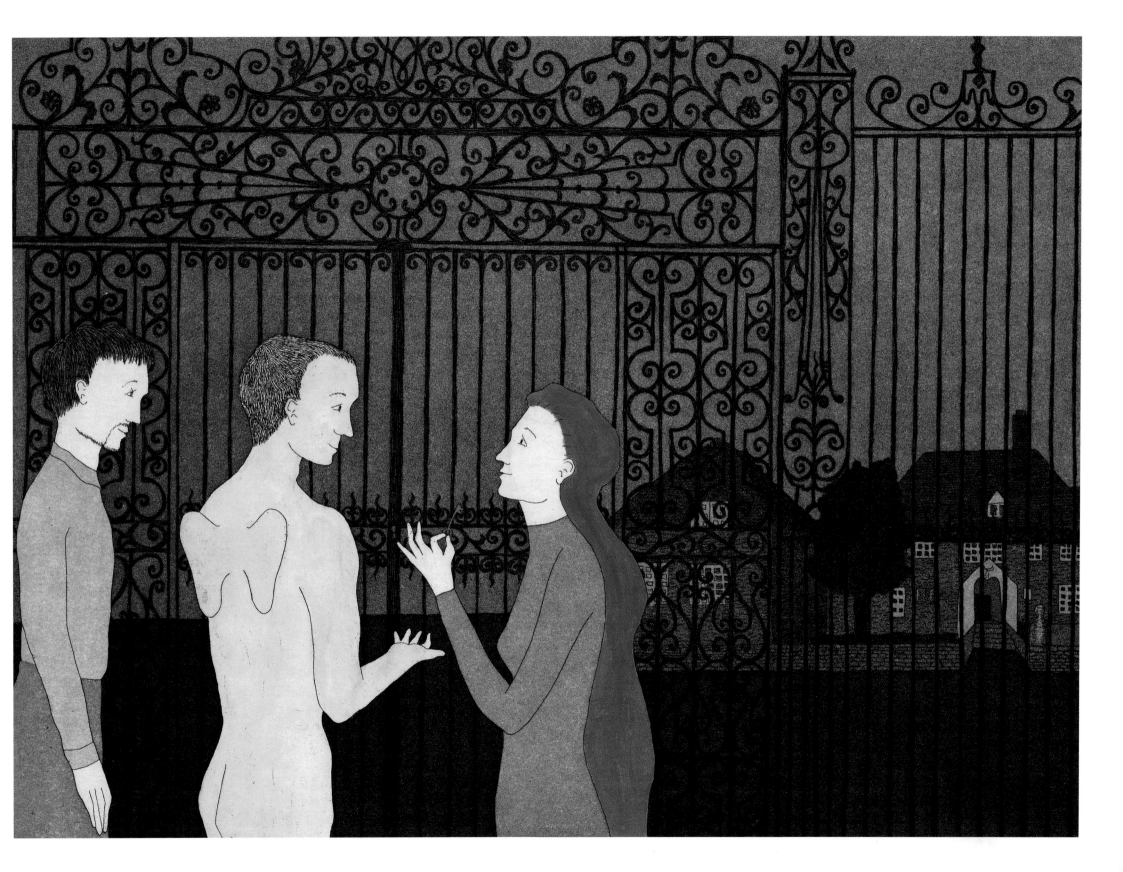

Many greetings:

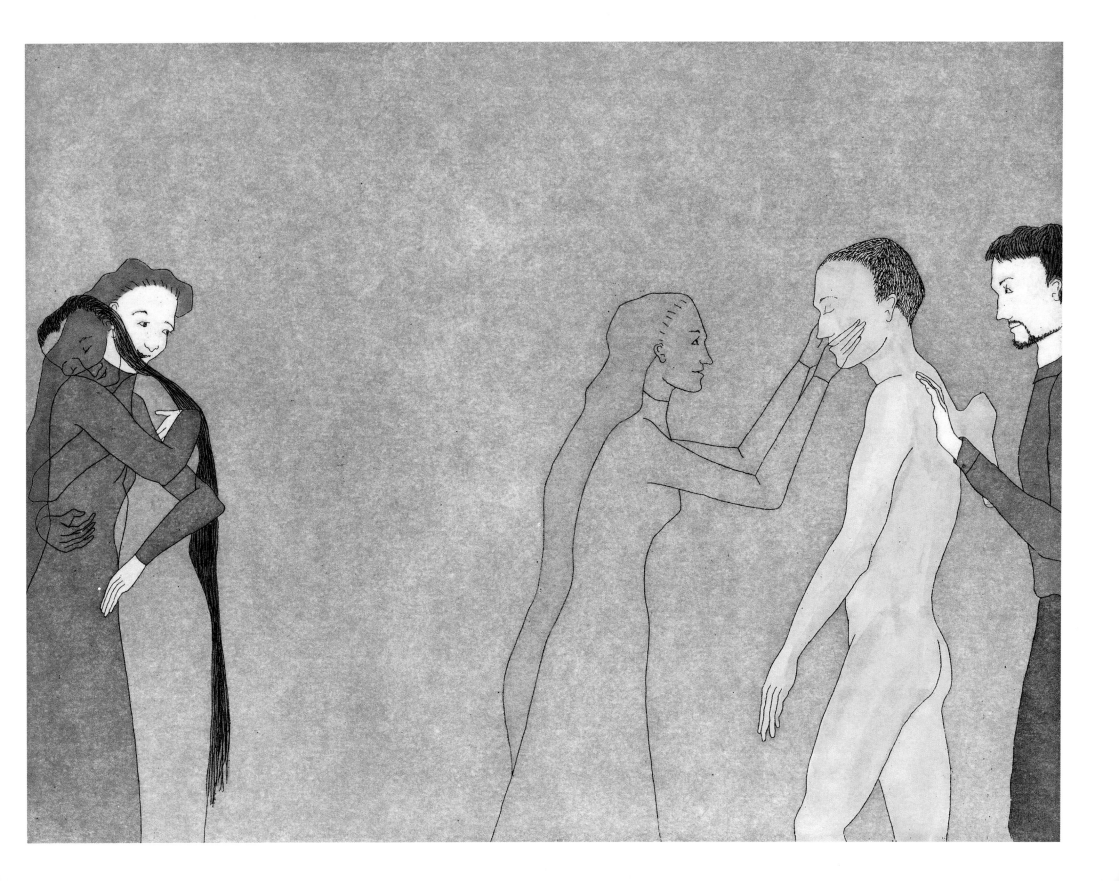

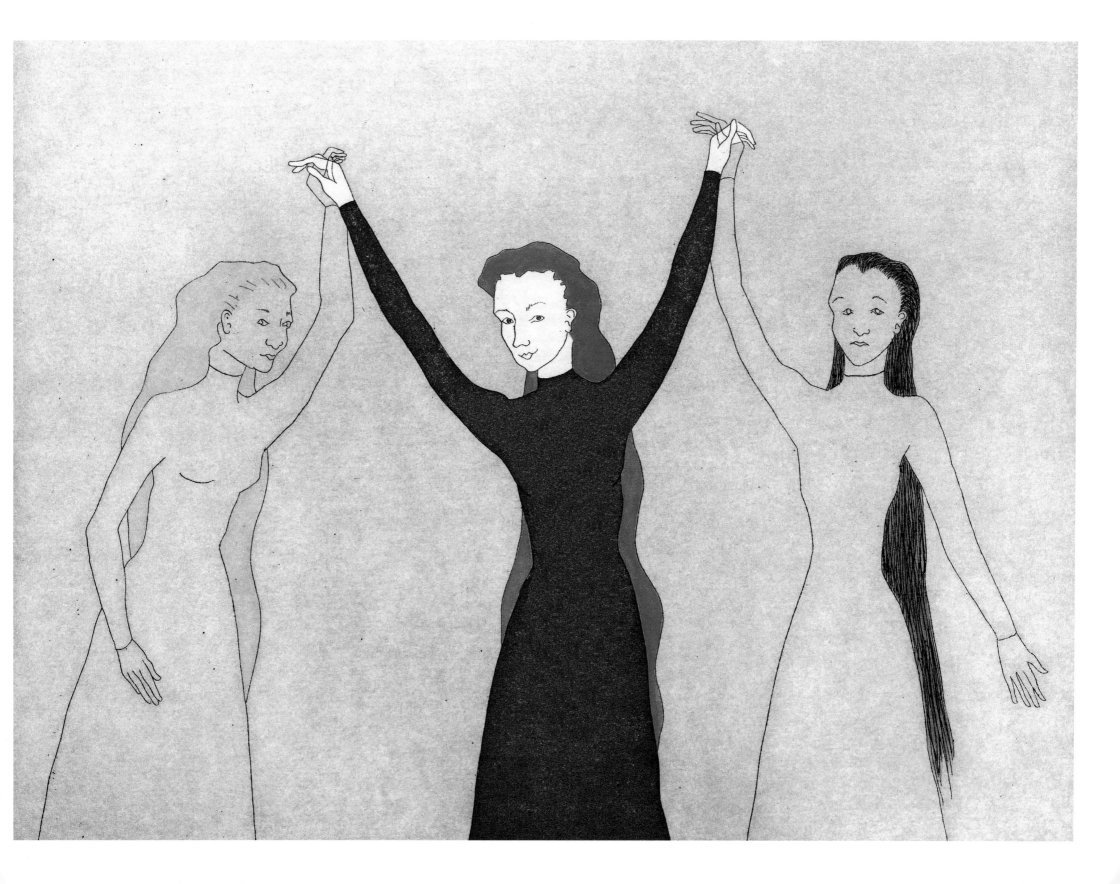

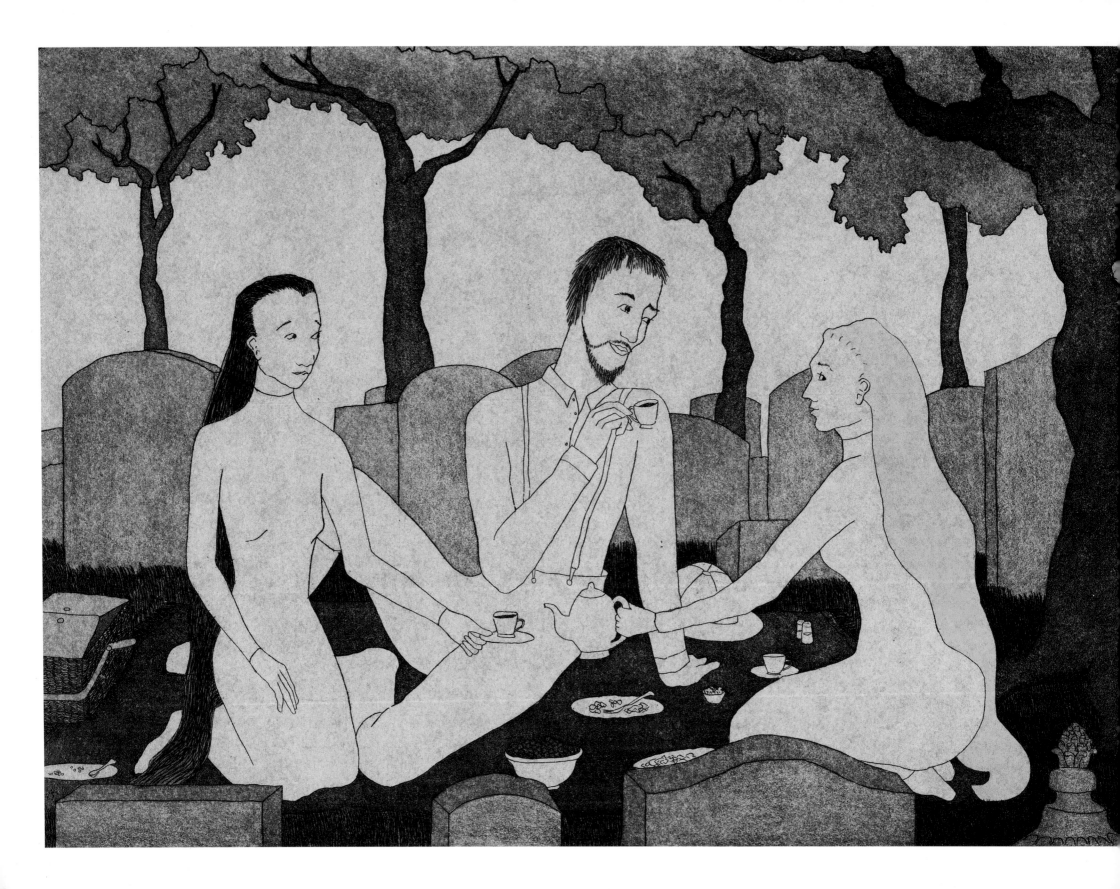

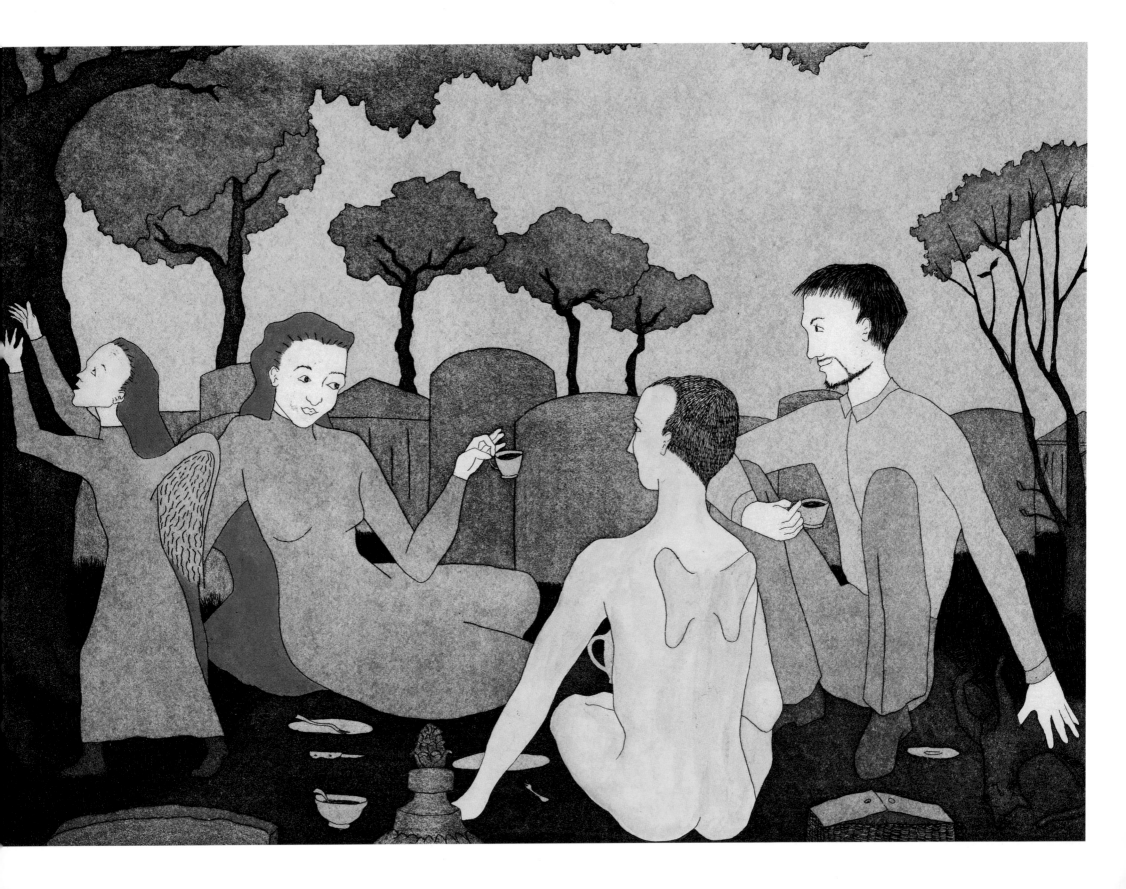

Afterword

This is the book of my heart, a fourteen-year labor of love.

The Three Incestuous Sisters's first incarnation was as an artist's book, in a handmade edition of ten. I created the story in pictures, sketching page spreads the way a director might work out the storyboard for a film. I wrote the text; as the images gained in complexity, the text dwindled until the weight of the story was carried by the images. I then spent most of the next thirteen years making the aquatints, designing the book, and setting and printing the type. The final year of the project was spent binding the books, elaborately, in leather. I make books because I love them as objects; because I want to put the pictures and the words together, because I want to tell a story. I call the books I make *visual novels* to acknowledge a debt to Lynd Ward, whose "woodcut novel" *Gods' Man* was the first book of this kind I ever saw, and to differentiate my books from graphic novels.

These images are aquatints. They are made by covering a zinc plate with an acid-resistant ground, drawing through the ground with a needle, and immersing the plate in a nitric acid bath, which results in a plate that has the lines of the drawing etched into it. To create tone, fine rosin dust is melted onto the plate.

I block out areas that should not be bitten by the acid, and the plate is placed in the acid bath in successive stages. I am working in reverse, and blind; I don't know what's actually on the plate until I print it. The color is watercolor, painted onto each print. Aquatint is an idiosyncratic, antique process, which for some reason makes me love it all the more.

A teacher of mine once invited my classmates and me to his studio. He was working on six paintings simultaneously, and when someone inquired about this, he explained that he could make one painting a week, or six paintings in six weeks. He preferred the latter, because then all the paintings were being made over a longer period of his life, and thus the end result was richer. I thought about this frequently during my long siege on this fortress of a book, and he was right. *The Three Incestuous Sisters* became itself through the passage of time and gradual changes in my skill and imagination.

During the years I worked on *The Three Incestuous Sisters* I went to graduate school; moved; started Green Window Printers with Pamela Barrie and moved that nine years later; went to Europe five times; and had eight solo exhibitions, four love affairs, three cats, and several hundred students. I also began to work on my first "real" novel, *The Time Traveler's Wife*, which started its life as the project I played with when I should have been finishing the *Sisters*.

When I try to explain *The Three Incestuous Sisters* to someone who hasn't seen it, I tell them to imagine a silent film made from Japanese prints, a melodrama of sibling rivalry, a silent opera that features women with very long hair and a flying green boy. I never try to explain what it means; you can find that out for yourself. I'm glad that it has finally completed its long journey from my mind to yours. Enjoy.

Audrey Niffenegger

November, 2004

Acknowledgments

The Three Incestuous Sisters is a book with a double life: it began as a hand-printed work of art, and now it is the book you are holding in your hands, which has come into being through the auspices of modern printing technology and the good graces of many people.

This edition of *The Three Incestuous Sisters* would not exist without the vision and perseverance of Tamar Brazis, Howard Reeves, Celina Carvalho, and Becky Terhune of Harry N. Abrams. Dan Franklin of Jonathan Cape was the first to say "Yes." He gave me hope that it could happen, and has been a source of encouragement and support. And Joseph Regal is the magician; he conjured up this edition after I had despaired. I thank you all.

Many, many people and institutions were helpful in the making of the original book. I received grants from the Vogelstein Foundation and the Union League Club. The wonderful Ragdale Foundation gave me residencies at critical junctures; the Evanston Art Center and Northwestern University provided me with printmaking facilities. I thank Sid Block and Bob Hiebert of Printworks Gallery for their patience, their humor, and their unending and multitudinous labors on my behalf; Marilyn Sward, my friend and mentor;

Andrea Peterson and Jon Hook, who made the paper for the original edition; my teachers Heinke Pensky Adam and Philip Chen; and Pamela Barrie, Bill Frederick, Paul Gehl, Mary Kennedy, Riva Lehrer, Amy Madden, Bert Menco, John Rush, and Claire Van Vliet for their critiques, suggestions, and friendship. Brandy Agerbeck and Kate Carr helped with the printing. I would also like to thank the collectors whose support enabled me to complete the book: Mary Jean and Cameron Thompson, Annette and Scott Turow, Drs. Robert and Barbara Kirschner, Dr. Andrew Griffin, Jerry and Carol Ginsberg, Renee Wallace, Hanna and Sidney Block, and the Houghton Library at Harvard University.

Loud, long thanks to my family, Patricia, Lawrence, Beth, and Jonelle, for their love and their help in all things, and to Christopher Schneberger, my complementary color, without whom everything would be black and white.